Basic Perspective

Basic Perspective

Robert W. Gill

with 83 illustrations

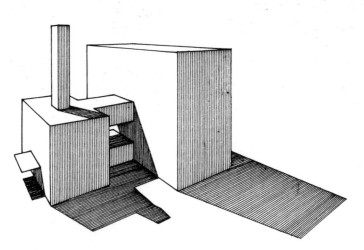

 Thames and Hudson

© 1974 Thames and Hudson Ltd, London

Reprinted 1988

Printed in the German Democratic Republic

Contents

Introduction 7

1 Terms used in perspective projection 13

2 Drawing the perspective: one-point and two-point 35

3 Three-point perspective: objects inclined to the 71
ground plane

4 Perspectives with an inclined picture plane 85

Conclusion 93

Index 95

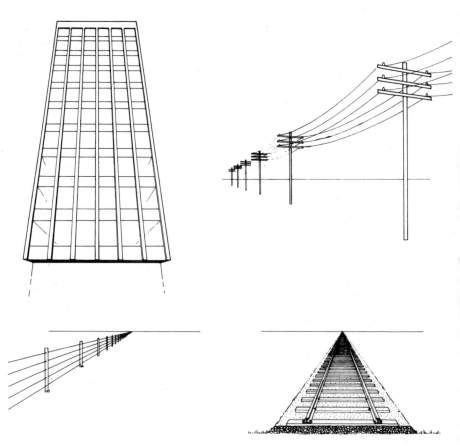

1 Some of the special effects of perspective
—convergence, foreshortening and diminution.

Introduction

It is impossible to look at an object or view without being aware of the existence of perspective, the optical effect which gives a sense of distance and solidity to what is seen.

The examples shown in Fig. 1 are well known, and either these or similar ones are seen daily. Parallel railway lines appear to converge or come together as they recede into the distance. Tall buildings, when looked at from street level, appear to taper as they recede from the spectator. This is known as 'convergence'.

The spaces between the telegraph poles and between the fence posts (though we know that they are equally spaced) appear to get smaller as they recede from the spectator. This is known as 'foreshortening'.

The telegraph poles and the fence posts also appear to become smaller as they recede from the spectator. This is known as 'diminution'.

From these examples it can be seen that convergence, foreshortening and diminution occur simultaneously, but for convenience they are discussed separately. (See Figs. 2 – 4 for further examples of these factors occurring simultaneously.) By examining the examples shown, it is possible to observe and set down a number of visual rules. The most important of these is that parallel lines appear to converge as they recede from the spectator. The second of these rules is that equal distances appear to become foreshortened as they recede from the eye. The third visual rule is that objects of similar size appear to diminish in size as they recede.

Perspective drawing is a linear presentation, and therefore these three visual rules are the main ones that concern us here, but there are other factors which can also be observed when looking at an object or view. Shade and shadow play an important part in helping us to get a complete picture of a view or object. Shade exists when a surface is turned away from the light; shadow exists when a surface is facing the light but the light is prevented from reaching it by an intervening object.

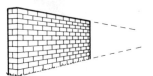

VIEW OF BRICK WALL AS SEEN BY SPECTATOR 2.

VIEW OF BRICK WALL AS SEEN BY SPECTATOR 1.

SPECTATOR 2.

SPECTATOR 1.

2 Convergence. In the view of the brick wall seen by spectator 1, the top and bottom lines and all other lines parallel to these will be horizontal (parallel to the ground). In the view seen by spectator 2, these lines no longer appear parallel or horizontal but, instead, seem to come together as they recede. In this view of the brick wall, not only do the lines converge but the true length of the wall no longer appears.

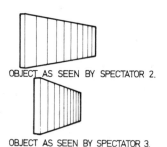

OBJECT AS SEEN BY SPECTATOR 2.

OBJECT AS SEEN BY SPECTATOR 3.

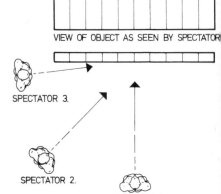

VIEW OF OBJECT AS SEEN BY SPECTATOR

SPECTATOR 3.

SPECTATOR 2.

SPECTATOR 1.

3 Foreshortening. The view of the object as seen by spectator 1 is the true length. The views seen by spectators 2 and 3 appear shorter the further round the spectator moves from the 'straight-on' view. The vertical lines on the face of the object are equally spaced over its whole length, but as the object is rotated and the distance between the spectator and the lines increases, the spacing between the lines, and their length, seem to diminish.

4 Diminution. Objects in perspective appear smaller as their distance increases.

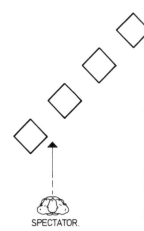

SPECTATOR.

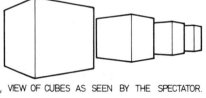

VIEW OF CUBES AS SEEN BY THE SPECTATOR.

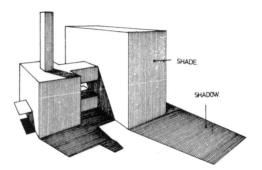

5 Shade and shadow. Light is needed to see an object, but in reality it is only the shades and shadows created by the light that are used in the rendering of an object.

SHADE.

SHADOW.

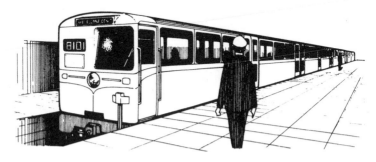

6 Diminution of detail as distance increases.

7 Diminution of tone and colour with distance—the 'atmospheric effect'.

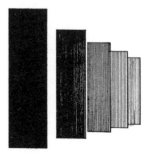

We can also see more *detail* on an object viewed from a short distance than when it is seen from further away. In Fig. 6, detail diminishes as the distance between the spectator and the carriages increases, and is only suggested at the far end of the train; as the eye travels along the train it helps to 'fill in' the missing detail. Note that the reduction of detail is not only desirable to give a sense of perspective but is also necessary because of the greatly reduced size of the farthest carriage.

Tone and colour tend to become greyer or more neutral as the distance from the spectator increases. The five surfaces in Fig. 7, all assumed to have the same dark tone, appear to become greyer as

9

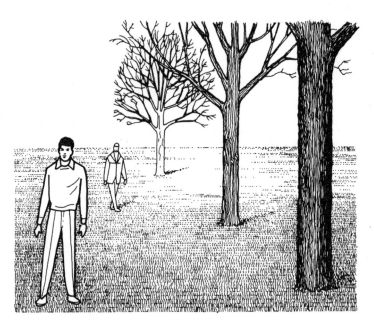

8 Diminution of texture and pattern with
distance.

they are seen from farther and farther away; similarly, light tones
become greyer as the distance from the spectator increases. Colours
are bright and clear when close to, but, like tones, they become
greyer or more neutral as their distance increases.

Textures and patterns appear clearer and more detailed when close
to the spectator than when viewed from a distance. Blades of grass,
the bark and leaves of trees and the features of people are seen clear-
ly by a spectator close to them, but as the distance from the specta-
tor increases he sees less and less detail until only a lawn or a tree or
a person can be distinguished.

Although convergence, foreshortening and diminution are basic to
a sense of depth and space in a drawing of a three-dimensional
object, shade and shadow, detail, tone and colour together with tex-
ture and pattern are important when the perspective drawing is to
be rendered.

A thorough understanding of these seven basic principles of per-
spective is necessary to all draughtsmen engaged in representational
drawing. These principles are applied to different purposes and with
varying degrees of thoroughness by artists, architects, engineers,
industrial designers, interior designers, illustrators and others. Once
the basic principles are understood it will be found that their appli-
cation to actual problems will help to produce greatly improved
drawings based on visual facts instead of vague guesswork.

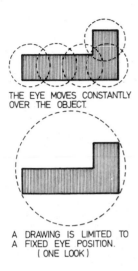

THE EYE MOVES CONSTANTLY
OVER THE OBJECT.

A DRAWING IS LIMITED TO
A FIXED EYE POSITION.
(ONE LOOK)

9 The difference between a fixed eye
position and a moving eye when looking at
an object.

First, it is necessary to understand how we look at things. When
looking at an object or view our eyes constantly move and change
focus to take in the over-all appearance together with its detail,
colour and size. From this we form a mental picture of the object
or view together with its relationship to other objects around it.
However, a drawing of this object or view is limited to one 'look'
or a fixed eye position (like that of the camera), and from this
one 'look' it is possible to produce a drawing, just as it is possible to
take a photograph of it with a camera. There are other factors which
affect this also (see *Cone of Vision,* p. 16), but at this point it is
necessary only to understand the 'one-look' principle as applied to
drawing.

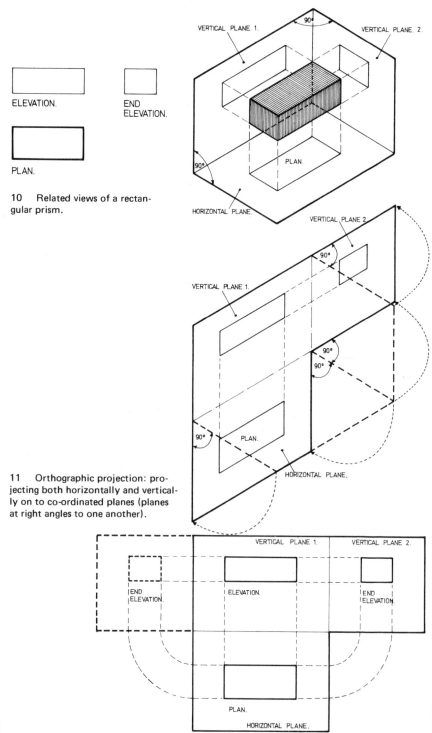

ELEVATION.

END ELEVATION.

PLAN.

10 Related views of a rectangular prism.

VERTICAL PLANE. 1.

VERTICAL PLANE. 2.

90°

90°

PLAN.

HORIZONTAL PLANE.

VERTICAL PLANE 2

90°

VERTICAL PLANE 1

90°

90°

90°

PLAN.

HORIZONTAL PLANE.

11 Orthographic projection: projecting both horizontally and vertically on to co-ordinated planes (planes at right angles to one another).

VERTICAL PLANE 1.

VERTICAL PLANE 2.

END ELEVATION.

ELEVATION.

END ELEVATION.

PLAN.

HORIZONTAL PLANE.

1 Terms used in perspective projection

The most important thing to understand from the beginning is that a perspective drawing can show only that which can be seen from a specific viewpoint. A perspective drawing is a technical drawing, unlike the artist's drawing, which is his own interpretation of what he sees. It is because a perspective drawing is a technical drawing that an accurate system of setting up is necessary. The system shown here is considered the most accurate yet evolved, and produces as nearly as possible a drawing of a three-dimensional object which coincides with the actual view of the object seen from the chosen viewpoint.

The first requirement when setting up a perspective view of an object is to obtain accurate information. This information is usually in the form of plans, elevations and sections. It is from the plan, usually, that the perspective view is projected (a plan of suitable size should be obtained), and heights etc. are measured from the elevations and sections. For the purpose of explanation the plan and elevations of a simple rectangular prism are shown in Fig. 10, using orthographic projection.

Orthographic projection is simply the method of drawing three-dimensional objects in two dimensions by means of related views called plans, elevations and sections. This means a parallel or perpendicular projection. Most buildings, furniture and fitting designs are prepared in this way.

If the object is placed so that its sides are parallel to the co-ordinated planes, as shown in Fig. 11, the faces of the object (in this case a rectangular prism) can be projected back onto the planes parallel with the faces and the plans and elevations can be drawn.

To explain the next step fully it is necessary to imagine that the co-ordinated planes are 'hinged'. The horizontal plane is swung downwards through 90°, and the vertical plane 2 is swung round through 90° so that the three planes, i.e. the projections, will lie in the same plane, which allows the draughtsman to work in two dimensions when portraying three-dimensional objects. In actual

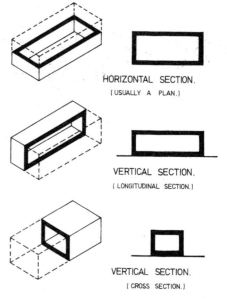

12 The sections used in orthographic projection, and their relationship to the actual object.

HORIZONTAL SECTION.
(USUALLY A PLAN.)

VERTICAL SECTION.
(LONGITUDINAL SECTION.)

VERTICAL SECTION.
(CROSS SECTION.)

practice the projection is made by first drawing the plan, then the front face (elevation) immediately above and the end elevation beside the front elevation. This is known as 'first-angle' projection, and it means that each view is so placed that it represents the face of the object remote from it in the adjacent view.

The first-angle projection is used in the British Isles and in Europe generally, Holland being the exception. The Dutch, like the Americans, use what is known as 'third-angle' projection, in which the plan is immediately above the elevation of the front face of the object. The end elevation, which is placed next to the front elevation, is of the adjacent end. In practice, architects often combine both first- and third-angle projections, so that the plan is located as in first-angle projection and end elevations are placed as in third-angle projection. This arrangement is recommended for general use.

Sections

A section is a view of an object when it has been cut straight through in (usually) either a vertical or horizontal direction. The most-used sections are illustrated in Fig. 12 but they by no means cover all the possibilities. The horizontal section is the plan (sectional plan), and usually there is a plan or horizontal section at each floor level in a building, including the foundations and the roof. If the object is cut longitudinally and vertically the view is called a longitudinal section, or long section. If the object is cut across and vertically, the view is known as a cross section.

13 Selection of station point in relation to an object.

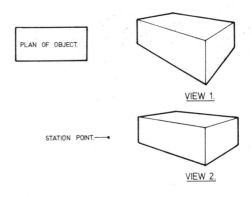

PLAN OF OBJECT.

VIEW 1.

STATION POINT.——•

VIEW 2.

Sections are used in orthographic projection to show interior details and/or details of construction. Therefore sections should be taken through important parts of objects and buildings.

Station point

This is the chosen point from which the object is to be viewed. It is also known by other names, such as the 'observer', 'viewing point' or 'eye position', but 'station point' is preferred by most authorities.

The station point should always be chosen in relation to the nature of the object. A station point chosen too close to an object will give a dramatic appearance to the perspective drawing which is seldom acceptable. It is usually advisable to avoid this effect by moving a little further back from the object.

Selecting a suitable station point is a matter of judgment and experience, and it should never be finally chosen until its position has been checked with the 'cone of vision' and also the size of the final drawing considered. (See *Cone of Vision*, p. 16, and *Picture Plane*, p. 19.) It is often advisable, when selecting the position of a station point, to look at a similarly-shaped object: if you are drawing a rectangular prism, look at a cigarette packet or a matchbox, as a check.

Unless otherwise stated, the height of the eye above the ground at the station point is taken as 5 ft.

In Fig. 13, view 1 shows a perspective drawing of a rectangular prism resulting from a badly chosen station point. Distortion is clearly evident, which makes this view unacceptable. The remedy in this case is simply to move the station point further back from the object. View 2 shows another perspective drawing of the same rectangular prism resulting from a much better position for the station point. The lack of distortion makes this view acceptable.

15

14 Station point and centre line of vision (plan).

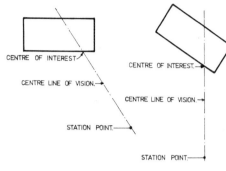

15 Station point and centre line of vision (elevation).

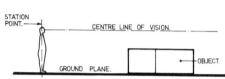

Centre line of vision

The centre line of vision, or, as it is sometimes known, the 'direct line of vision' or the 'direct line of sight' in perspective drawing is a line from the station point to the centre of interest of the object – in other words, the point on which the eye is fixed. This line is always represented as a vertical line in perspective drawing. When the station point is located and the direction of the view (centre line of vision) is decided upon, the plan should be turned round until the centre line of vision is vertical, and usually with the station point at the bottom. This is done for convenience, to make it easier to produce a perspective drawing using a T-square and a set-square. The centre line of vision is always taken to be parallel to the ground plane, which is shown as a horizontal plane for the purpose of perspective drawing (see *Ground Line,* p. 31).

Cone of vision

The field of vision is known to be more than 180° but it is not possible to see clearly over this whole range. The normal maximum range within which it is possible to see clearly and easily is accepted as being a cone of less than 90° and is seldom if ever shown as more than 60°. For the purpose of perspective drawing it is usually limited to 60° or less. Where possible, the student is advised to use a cone of vision of much less than 60°, say 45° or even 30°, as these will normally be adequate for his purposes and will give a much more satisfactory result than a wider cone of vision.

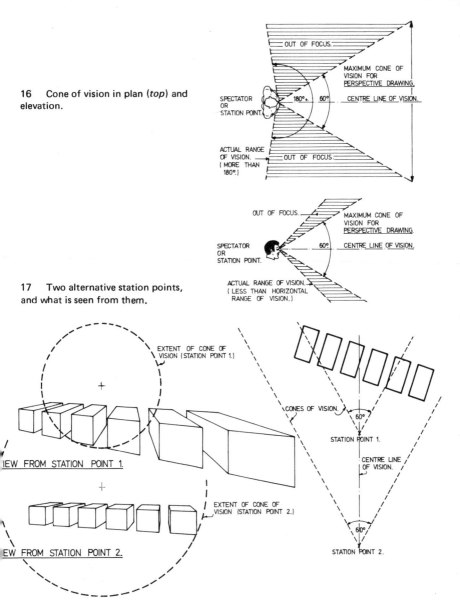

16 Cone of vision in plan (*top*) and elevation.

17 Two alternative station points, and what is seen from them.

As can be seen from the diagrams, any object or part of an object which would not normally be seen clearly because of its lying outside this cone of vision will be distorted if we try to draw it. To obtain a wider coverage with the cone of vision it is necessary to move back from the object; it is not enough simply to widen the cone of vision. When deciding on the position from which to view the object it is necessary to fit the whole — or the part which is to be included in the drawing - inside the cone of vision. This fact governs

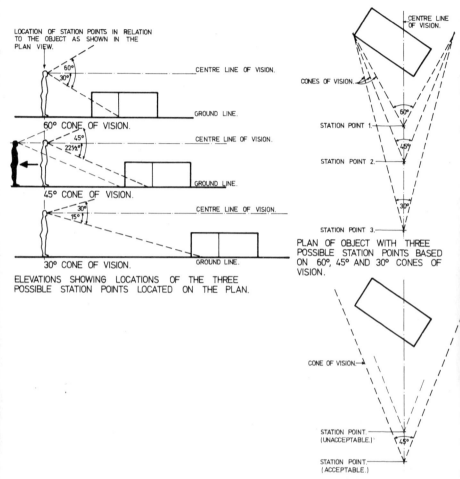

LOCATION OF STATION POINTS IN RELATION TO THE OBJECT AS SHOWN IN THE PLAN VIEW.

CENTRE LINE OF VISION.

GROUND LINE.

60° CONE OF VISION.

CENTRE LINE OF VISION.

GROUND LINE.

45° CONE OF VISION.

CENTRE LINE OF VISION.

GROUND LINE.

30° CONE OF VISION.

ELEVATIONS SHOWING LOCATIONS OF THE THREE POSSIBLE STATION POINTS LOCATED ON THE PLAN.

CENTRE LINE OF VISION.

CONES OF VISION.

STATION POINT 1.

STATION POINT 2.

STATION POINT 3.

PLAN OF OBJECT WITH THREE POSSIBLE STATION POINTS BASED ON 60°, 45° AND 30° CONES OF VISION.

CONE OF VISION.

STATION POINT. (UNACCEPTABLE.)

STATION POINT. (ACCEPTABLE.)

PLAN OF OBJECT WITH CONFIRMED STATION POINT USING A 45° CONE OF VISION.

18 Cone of vision: examples of its use to locate the limits of a drawing.

the distance from which one should view the object. When a station point is being considered and its position checked with the cone of vision, it should be checked on the plan and also on the elevation. The reasons for this will be obvious when the object is, for example, a tall building.

The centre line of this cone is the centre line of vision. This line is represented in plan by a vertical line and in elevation by a horizontal line. The apex of this cone is the station point.

From examination of Fig. 18 a number of points can be learned. The first of these is that the smaller the angle for the cone of vision, the greater the distance required between the object and the station point to obtain the same coverage. The second is that even though the plan of the cone of vision appears to confirm the location of the station point, when this is checked in the elevation it can be seen that in each case the station point must be moved further back from the object. (For the purposes of illustration it is intended to use a 45° cone of vision for the examples in this book.)

The elevation of the 45° cone of vision shows the station point repositioned so that the whole of the object falls within the cone of vision. (The repositioned figure is shown in black.) This means that a perspective drawing made using the new confirmed station point will not contain distortions.

It can be seen that it is the cone of vision that governs the distance of the station point from the object. Ignorance of this fact is responsible for many of the badly distorted perspective drawings that are produced.

Picture plane

This is an imaginary vertical plane on which the perspective drawing is supposed to be done. The perspective drawing is in fact the plotting of the positions where the visual rays from the eye (station point) through the points of the object intersect the picture plane. Imagine a fixed eye position looking through a sheet of glass (e.g. a window). It would be possible to trace the shape of the object on the glass exactly as it is seen. As shown in Fig. 19, this principle remains true whether the picture plane is placed in front of or behind the object.

In perspective drawing the picture plane is an imaginary plane, normally at 90° to the ground plane, on which the perspective drawing is supposed to be made. The picture plane can be inclined to the ground plane for special views, which are dealt with later (see *Aerial View*, p. 85), but in what are known as 'one-point' and 'two-point' perspectives the picture plane is always taken to be perpendicular.

From Fig. 19 it can be seen that the picture plane may be placed in front of, behind or, if necessary, even through the object. In other words, the location of the picture plane is a matter of personal choice and convenience, so long as it is perpendicular and at 90° to the centre line of vision.

19 The principle of the picture plane in relation to the object and the eye.

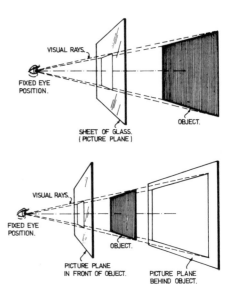

VISUAL RAYS.

FIXED EYE POSITION.

OBJECT.

SHEET OF GLASS. (PICTURE PLANE)

VISUAL RAYS.

FIXED EYE POSITION.

OBJECT.

PICTURE PLANE IN FRONT OF OBJECT.

PICTURE PLANE BEHIND OBJECT.

The exact situation shown in the diagram can be drawn in plan where the plan of the object, the station point (spectator) and the centre line of vision are prepared for perspective drawing as previously described. The plan view of the perpendicular picture plane will be represented by a straight line drawn in a selected position at 90° to the centre line of vision.

It will be obvious that the picture plane cannot remain perpendicular, as shown in Fig. 20, when a perspective drawing is being done on a flat sheet of paper. As explained on p. 12, a plane can be 'hinged' so that a vertical plane can be brought into the same plane as the horizontal plane for drawing purposes. This can be done without altering the image of an object drawn on the plane.

By using vertical projection, distances marked on the plan of the picture plane can be projected either above or below the plan of the picture plane to a selected position where the perspective drawing is to be made. This is explained more fully in Fig. 21.

The upper diagram in Fig. 21 shows the visual rays from the spectator (station point) passing through the points of the object and meeting the picture plane. From Fig. 19 it can be seen that by joining these points where the visual rays meet the picture plane the perspective view can be drawn. Also shown are the plans of the visual rays from the station point through the points of the plan of the object and meeting the picture plane. From this it can be seen that lines projected up from the points where the plans of the visual rays meet the picture plane coincide with the points of the perspective of the object. This simply means that by working

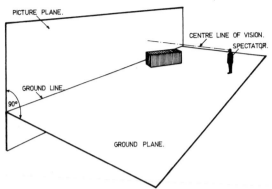

DIAGRAM SHOWING A SPECTATOR LOOKING AT AN OBJECT WITH A PICTURE PLANE PLACED BEHIND IT.

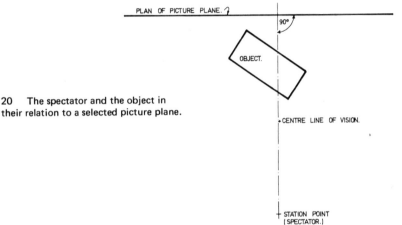

20 The spectator and the object in their relation to a selected picture plane.

PLAN OF OBJECT SET UP AS SHOWN IN THE DIAGRAM.

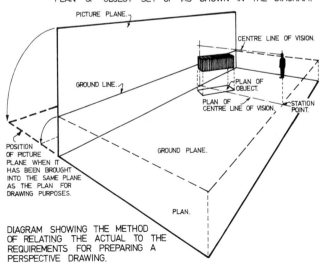

DIAGRAM SHOWING THE METHOD OF RELATING THE ACTUAL TO THE REQUIREMENTS FOR PREPARING A PERSPECTIVE DRAWING.

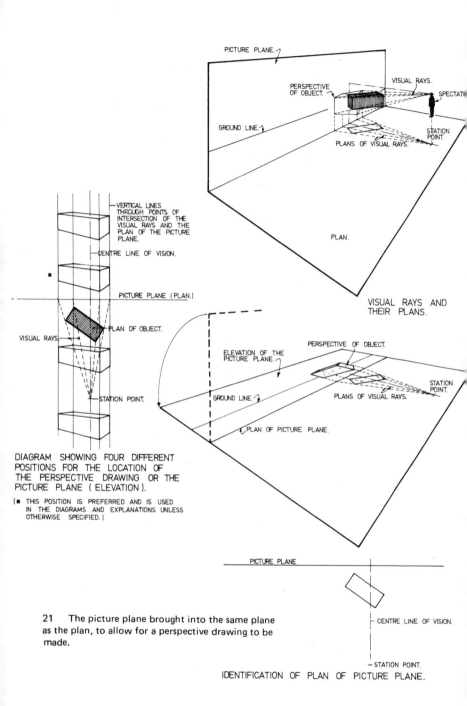

PICTURE PLANE.

PERSPECTIVE OF OBJECT.

VISUAL RAYS.

SPECTATOR

GROUND LINE.

STATION POINT.

PLANS OF VISUAL RAYS.

PLAN.

VISUAL RAYS AND THEIR PLANS.

VERTICAL LINES THROUGH POINTS OF INTERSECTION OF THE VISUAL RAYS AND THE PLAN OF THE PICTURE PLANE.

CENTRE LINE OF VISION.

PICTURE PLANE (PLAN.)

PLAN OF OBJECT.

VISUAL RAYS.

STATION POINT.

ELEVATION OF THE PICTURE PLANE.

PERSPECTIVE OF OBJECT.

STATION POINT.

GROUND LINE.

PLANS OF VISUAL RAYS.

PLAN OF PICTURE PLANE.

DIAGRAM SHOWING FOUR DIFFERENT POSITIONS FOR THE LOCATION OF THE PERSPECTIVE DRAWING OR THE PICTURE PLANE (ELEVATION).

(■ THIS POSITION IS PREFERRED AND IS USED IN THE DIAGRAMS AND EXPLANATIONS UNLESS OTHERWISE SPECIFIED.)

PICTURE PLANE

CENTRE LINE OF VISION.

21 The picture plane brought into the same plane as the plan, to allow for a perspective drawing to be made.

STATION POINT.

IDENTIFICATION OF PLAN OF PICTURE PLANE.

22

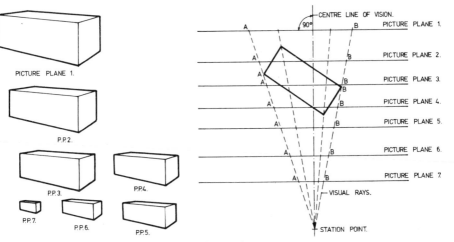

22a The effect of moving the picture plane: only
the size of the drawing is changed.

with a plan of the object together with a plan of the picture plane
it is possible to locate the vertical lines on which the points of
the object will be located on the elevation of the picture plane.

When the picture plane is swung down so that it falls in the
same plane as the plan, as shown in the lower diagram of Fig. 21,
it can be seen that the same situation occurs as described in the
first diagram. In this second diagram the picture plane (elevation)
is located above the plan of the picture plane but it should be
understood that the picture plane (the position where the perspec-
tive drawing is to be made) can be placed above, below or even on
top of the plan of the picture plane.

Once the principles of the picture plane are understood it is no
longer necessary to refer to the *plan* of the picture plane. In per-
spective drawing this line is usually referred to simply as 'the picture
plane', and this is the name which will be used in diagrams and
text from this point on.

The location of the picture plane is a matter of choice, conveni-
ence or control of the size of the perspective drawing required. The
closer to the spectator the picture plane is located the smaller the
drawing, and, naturally, the further away the larger the drawing.
However, it is only the *size* of the drawing which is affected; the view
of the object remains the same. Fig. 22a explains this.

By drawing the visual rays from the station point through the
points of the object to the selected picture plane the over-all size of
the perspective drawing can be measured. A check on the finished
size of the perspective drawing to be made at this point can save a

23

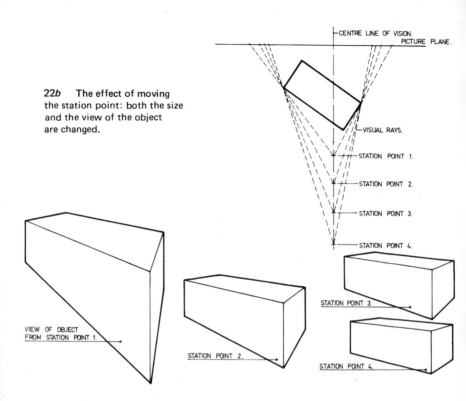

22b The effect of moving the station point: both the size and the view of the object are changed.

great deal of effort and time. The complete control of the size of the finished perspective drawing from the beginning is a valuable aid to anyone preparing any type of perspective drawing.

Fig. 22a shows seven different locations for the picture plane, chosen at random. Points A and B are the extreme ends of the object seen from the station point shown. These two points can be located as shown on each picture plane, and measurement of the distance between them will give the over-all length of a perspective drawn using each location for the picture plane.

By contrast, using a fixed picture plane and different station points changes not only the size of the drawing but also the view of the object. The diagram in Fig. 22b has four station points located at different distances from the object along a common centre line of vision. (For the purpose of illustrating this point the cone of vision has been ignored in the views from station points 1, 2 and 3.) By comparing the views of the object seen from the different station points it can be seen that they differ considerably from one another even when allowance is made for the obvious distortions in the view from station point 1.

A thorough understanding of these facts will enable the student, from the beginning of a project, to control the drawing size and fit a perspective drawing into any given size without difficulty.

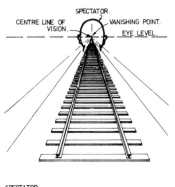

23 Why the vanishing point is at the obser-
ver's eye level.

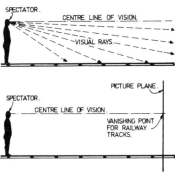

The position where it is intended to draw the perspective on the
paper is the picture plane in elevation. This can be clearly understood
by referring to Fig. 21, where the actual construction of the perspec-
tive drawing can be seen on the picture plane behind the object.

Vanishing points

Any two or more parallel lines will, if extended indefinitely, appear
to converge and meet at a point. This point is known as the vanishing
point. Regardless of direction, each set of parallel lines will converge
towards its own vanishing point.

In perspective drawing it is necessary to locate exactly the vanish-
ing points for parallel lines. To do this, the relationship between
parallel lines and sight lines must be understood. When a spectator
looks along railway lines, the centre line of vision is in fact parallel
to the tracks. (The centre line of vision is parallel to the ground
plane.) Because these lines are parallel they will converge until they
meet at a common vanishing point. The second diagram in Fig. 23
shows how the angle between the centre line of vision and the visual
rays decreases as the distance between the spectator and the point
observed increases. From this it can be seen that the visual rays will 25

24 The method of obtaining the vanishing points for a simple rectangular prism, and the actual vanishing points in relation to their plan positions.

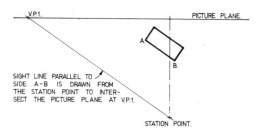

SIGHT LINE PARALLEL TO
SIDE A-B IS DRAWN FROM
THE STATION POINT TO INTER-
SECT THE PICTURE PLANE AT V.P.1.

STATION POINT.

VANISHING POINT 1 (V.P.1.) IS THE POSITION IN PLAN OF THE VANISHING POINT FOR SIDE A-B AND ALL SIDES AND LINES PARALLEL TO IT.

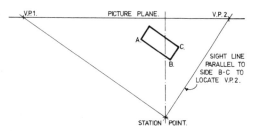

V.P.1. PICTURE PLANE. V.P.2.

SIGHT LINE PARALLEL TO SIDE B-C TO LOCATE V.P.2.

STATION POINT.

VANISHING POINT 2 (V.P.2) IS THE POSITION IN PLAN OF THE VANISHING POINT FOR SIDE B-C AND ALL SIDES AND LINES PARALLEL TO IT.

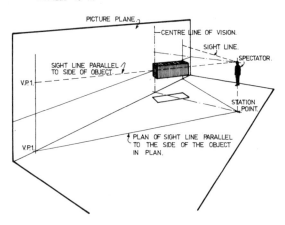

PICTURE PLANE.

CENTRE LINE OF VISION.

SIGHT LINE.

SPECTATOR.

SIGHT LINE PARALLEL TO SIDE OF OBJECT.

V.P.1.

STATION POINT.

PLAN OF SIGHT LINE PARALLEL TO THE SIDE OF THE OBJECT IN PLAN.

V.P.1.

finally coincide with the centre line of vision, which means that the vanishing point will be on the eye level.

Therefore the vanishing point for the railway lines is at the point at which the sight line (the centre line of vision in this case) parallel to them intersects the picture plane. Because the sight line, which is parallel to the railway lines, vanishes to the same vanishing point as the railway lines it can be assumed that all lines parallel to the railway lines will converge to the same vanishing point. From this it can be assumed that in all cases where a sight line parallel to a line or side of an object meets the picture plane (in plan), that point

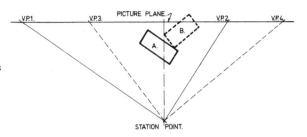

25 The method of obtaining vanishing points for two objects at different angles to the picture plane.

will be the vanishing point for the line or side of the object and all lines parallel to it.

Once the principle of locating vanishing points has been understood it can be applied to perspective drawing. It has been established in Fig. 23 that a sight line (the centre line of vision in the case of the spectator looking along the railway lines) parallel to a side of an object vanishes to the same vanishing point as all lines which are parallel to that side. This means that the method of finding the vanishing point for a side of an object is a simple matter of drawing a sight line parallel to the side. The point of intersection between the picture plane and the sight line is the vanishing point in plan.

By reference back to the explanation of the picture plane (p. 19) it can be seen that the actual location of the vanishing points will be above or below their plan position (depending on the location of the elevation of the picture plane). Also from the explanation, and from Fig. 23, it is known that the vanishing points for lines parallel to the ground plane will be on the eye level. (This is further explained in Fig. 29, p. 30.)

For objects at an angle to each other, since it has been established that each set of parallel lines will converge to a single vanishing point, by treating each object separately the vanishing points for each side can be found and each object drawn in perspective. This is also true for objects with more than four sides or irregularly-shaped objects. The important thing to remember is that each set of parallel lines will have its own vanishing point, so it does not matter how many different directions are included in any one object or group of objects. Provided the vanishing points are found for each set of parallel lines in each direction, any shape can be drawn in perspective.

Height lines

The height line in perspective drawing is the line used for measuring all vertical heights. These heights are measured using the same scale as that used for the plan and elevations. The location of this line is

27

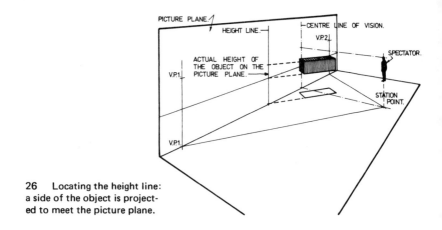

26 Locating the height line:
a side of the object is project-
ed to meet the picture plane.

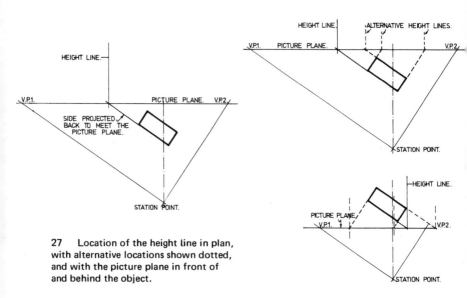

27 Location of the height line in plan,
with alternative locations shown dotted,
and with the picture plane in front of
and behind the object.

found by projecting a line as the continuation of a side of the object
in plan either backwards or forwards, as necessary, to meet the plan
of the picture plane. From this point a vertical line can be drawn on
the elevation of the picture plane and it is on this line that vertical
heights can be measured. Fig. 26 shows graphically the relationship
between the plan and the actual side of the object projected back to
meet the picture plane and the plan. From this it can be seen that
the top and bottom of the extended side meet the picture plane on
the line projected up from the plan location of the height line and
because the top and bottom lines are parallel the distance between
them is the same as the height of the object. Therefore actual heights
can be measured on the height line because the height line is in

28　A horizontal plane through the spectator's eye level intersecting the picture plane at the horizon line.

actual fact a continuation of the side being measured. This remains true for all the sides of the object, therefore the most convenient side should be chosen to be projected either backwards or (if the picture plane is in front of the object) forwards to the picture plane to locate the height line.

Fig. 27 shows the alternative locations for the height line when other sides are extended. It can be seen that any side can be extended but it should also be obvious that a convenient side should be used to locate the height line, otherwise inaccuracies can be expected. This is explained more fully later on in this book, but generally the side chosen should be one prominent in the view of the object from the selected station point, and for preference it should be on the side which has the greater distance between the centre line of vision and the vanishing point.

Eye level or horizon line

When the spectator's centre line of vision is parallel to the ground, the eye level coincides with the horizon line. This means that if a horizontal plane is drawn through the spectator's eye level it will meet the picture plane, producing a straight horizontal line parallel to the ground plane and the same distance above it as the spectator's eye. The line produced on the picture plane by the intersection of the horizontal plane through the eye level of the spectator is known as the eye level or the horizon line. (In perspective drawing, the term 'horizon line' is preferred, and will be used from here on.)

The important fundamental in perspective drawing is the height of the eye level above the ground plane. As previously described, the elevation of the picture plane can be located as convenient

29

29 Locating the vanishing points on the horizon line. Note that the various alternative locations for the horizon lines (*opposite*) do not alter the relationship between the vanishing points, the centre line of vision and the height line. Any of the alternative locations would be satisfactory for drawing the perspective view of the object.

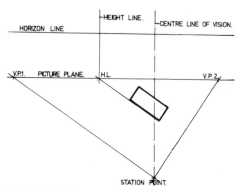

WHEN THE HORIZON LINE IS LOCATED THE ACTUAL VANISHING POINTS CAN BE LOCATED BY PROJECTING UP (IN THIS CASE) OR DOWN FROM THEIR PLAN POSITIONS LOCATED ON THE PLAN OF THE PICTURE PLANE.

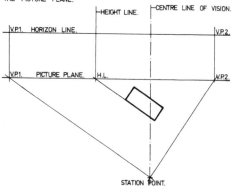

(within certain limits), so wherever the horizon line is drawn can be assumed to be the elevation of the picture plane – in other words, the position where it is intended to draw the perspective view. This is usually directly above or sometimes below the plan of the picture plane, whichever is more convenient. It is necessary in perspective drawing to project up (or down) from the plan of the picture plane to locate the vanishing points and the height line on the horizon line.

The positioning of the horizon line on the elevation of the picture plane is a matter of convenience. The position is limited only by the equipment and space available (i.e. the size of the drawing board and the length of the set square to be used for the vertical projections).

A few important points regarding the horizon line and its use are worth remembering. The horizon line in a perspective drawing shows the position of the spectator's eye level. It is advisable to draw objects using an eye level normally used for viewing that object in reality unless some special viewing position is required for some specific reason. Generally a horizon line placed towards the top of the picture or above it means a high eye level, sometimes called a 'bird's-

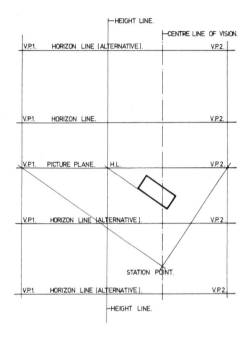

eye view'. This is often used in perspective drawing when the top of the object is important. The horizon line placed about the centre of the picture usually means a normal eye level (i.e. 5 ft. above the ground). A low horizon line (near the bottom of the picture) usually means a low eye level or 'worm's-eye view'.

When locating the horizon line on the picture plane it should be decided at what height the eye level is to be, so that space can be provided either above or below the horizon line as may be necessary for the perspective drawing to be done.

Ground line

The ground plane is a horizontal plane representing the ground on which the spectator and the object are supposed to stand or to which they are supposed to be related. The eye level of a spectator is measured as some distance above (or below) the ground, depending on the spectator's position relative to the ground, e.g. a spectator standing on the top step of a ladder will have a higher eye level than a spectator standing on the ground.

31

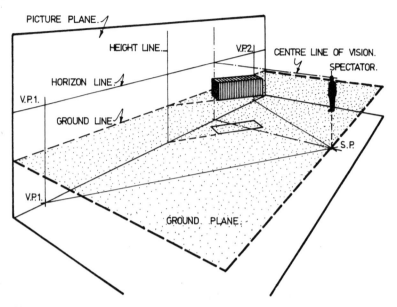

PICTURE PLANE.

HEIGHT LINE.

V.P.2.

CENTRE LINE OF VISION.

SPECTATOR.

HORIZON LINE.

V.P.1.

GROUND LINE.

S.P.

V.P.1.

GROUND. PLANE.

30 The relationship between the ground line and
the horizon line.

The ground line is the intersection of the ground plane and the
picture plane. This is explained graphically in Fig. 30, where the
object and the spectator are shown in relation to the ground plane
and the picture plane. The spectator is standing on the ground in
what is known as the 'normal' position, that is to say the eye level
is assumed to be 5 ft. above the ground. Unless something different
is specified, this assumption is always made.

The ground line is seen to be a horizontal line parallel to the hor-
izon line. In perspective drawing, the ground line is located (Fig. 31)
by measuring down from the horizon line the distance of the select-
ed eye level (using the same scale as that used for the plan and eleva-
tions) and at this point a horizontal line is drawn, representing the
ground line. This places the ground line at the required distance be-
low the horizon line or the spectator's eye level. In other words, the
horizon line and the ground line are related to each other so as to
produce a perspective drawing of an object when looked at from this
specific eye level.

The location of the horizon line is a matter of convenience but
the ground line is always located in relation to the horizon line,
therefore they should be thought of as inseparable, and when the
horizon line is located the ground line should be located with it.

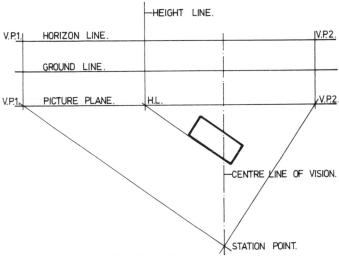

31 The distance between the horizon line and the ground line, as it would be measured on the height line in setting up a perspective drawing.

In practice the ground line need be located only where it intersects the height line, which means that the height line should be used to measure the distance between the horizon line and the ground line. The reason for this will become obvious as the method of drawing the perspective view is described.

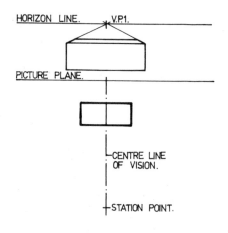

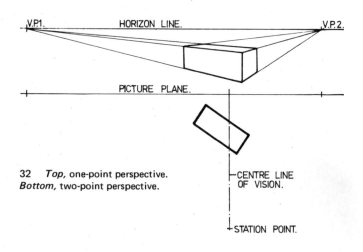

32 *Top,* one-point perspective.
Bottom, two-point perspective.

2 Drawing the perspective: one-point and two-point

With the location of the ground line the preparations for drawing the perspective view are complete. All that remains is for the actual perspective view to be drawn, but before proceeding to this it is necessary to understand the various types of perspective drawing in general use.

There are three types of perspective drawing. Each type has a different relationship between the lines of the object and the picture plane. In perspective drawing, any set of parallel lines may be parallel to, at right angles to, or oblique to the picture plane. Lines which are parallel to the picture plane remain parallel in the perspective. A set of lines which are at right angles to or oblique to the picture plane vanish to a vanishing point in perspective. The three types of perspective drawing are distinguished by the number of vanishing points required by each type.

One-point perspective has two sets of lines parallel to the picture plane and a third set at right angles to it. Since a set of parallel lines not parallel to the picture plane converges to a vanishing point, this set-up will require only one vanishing point and is called 'one-point' perspective.

Two-point perspective has one set of lines parallel to the picture plane (the vertical lines only) and two sets oblique to it. Parallel lines oblique to the picture plane converge to a vanishing point, which means that this set-up will require two vanishing points.

Three-point perspective has three sets of lines oblique to the picture plane, thus requiring three vanishing points. Three-point perspective is more difficult to construct than the other two types and is not used as frequently as the others. It is not illustrated at this stage, but is dealt with later (p. 71).

The most-used type of perspective drawing is probably two-point perspective; because of this, the explanations used so far have been illustrated with two-point principles, but as will be seen these principles remain true for each of the three types of perspective drawing.

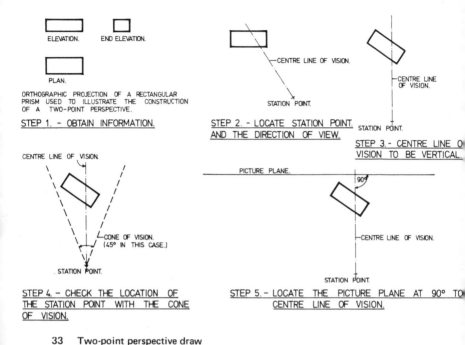

ELEVATION. END ELEVATION.

PLAN.

ORTHOGRAPHIC PROJECTION OF A RECTANGULAR PRISM USED TO ILLUSTRATE THE CONSTRUCTION OF A TWO-POINT PERSPECTIVE.

STEP 1. - OBTAIN INFORMATION.

—CENTRE LINE OF VISION.

STATION POINT.

STEP 2. - LOCATE STATION POINT. AND THE DIRECTION OF VIEW.

—CENTRE LINE OF VISION

STATION POINT.

STEP 3. - CENTRE LINE OF VISION TO BE VERTICAL.

CENTRE LINE OF VISION.

CONE OF VISION. (45° IN THIS CASE.)

STATION POINT.

STEP 4. - CHECK THE LOCATION OF THE STATION POINT WITH THE CONE OF VISION.

PICTURE PLANE.

90°

—CENTRE LINE OF VISION.

STATION POINT.

STEP 5. - LOCATE THE PICTURE PLANE AT 90° TO CENTRE LINE OF VISION.

33 Two-point perspective draw
ing: steps 1-5.

Two-point perspective drawing

Figs. 33–35 show the steps for the preparation of a plan and the set-ting up of conditions for the drawing of a perspective view of an ob-ject. If these steps are followed in the sequence shown here, it will be found that perspective drawings can be prepared quickly and accurately.

Step 1. Either obtain or prepare information regarding the object, i.e. plan, elevations and, if necessary, sections. For the purposes of illustration the same rectangular prism is used as for the pre-ceding explanations, and it is shown in orthographic projection.

Step 2. Select the direction of the view and the station point, i.e. the centre line of vision and the position from which it is pro-posed to view the object.

Step 3. In perspective drawing, the plan of the centre line of vision is always drawn as a vertical line, so it is necessary to rotate the plan and the station point until the centre line of vision is vertical.

34a Two-point perspective drawing: steps 6 and 7.

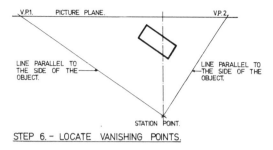

STEP 6. – LOCATE VANISHING POINTS.

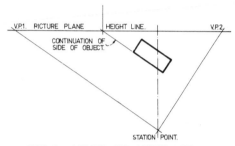

STEP 7. – LOCATE THE HEIGHT LINE.

Step 4. The location of the station point should be checked at this stage with the cone of vision. (The cone of vision suggested in the earlier explanations was 45°.) If the whole of the object intended to be included in the drawing falls within this cone of vision, the position of the station point can be taken as confirmed. If not, it will be necessary to move the station point back from the object. (It is not sufficient to simply widen the cone of vision: see Figs. 16-18, *Cone of Vision.*)

Step 5. Locate the picture plane in the desired position. The picture plane is always drawn at 90° to the centre line of vision. (See Figs. 19-22 for an explanation of the picture plane.)

Step 6. Locate the two vanishing points required for the perspective drawing of this object from this station point. From the station point draw lines parallel to the sides of the object to meet the picture plane. Where these lines and the picture plane intersect are the required vanishing points. (See Figs. 24 and 25 for an explanation of the vanishing points.)

Step 7. Locate the height line by projecting a convenient side of the plan of the object to meet the picture plane. (See Fig. 27 for an explanation of the height line.)

34*b* Two-point perspective
drawing: steps 8 and 9.

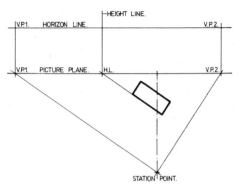

STEP 8. - LOCATE THE HORIZON LINE AND
PROJECT UP TO LOCATE VANISHING POINTS
ON THE HORIZON LINE.

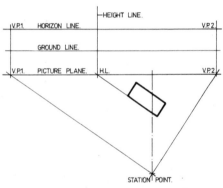

STEP 9. - LOCATE THE GROUND LINE.

Step 8. Locate the horizon line in a convenient position either
above or below the plan. In this example it is intended to draw
the perspective view above the plan, so the horizon line is drawn
at a convenient height above the picture plane. Project up from
the plan the positions of the vanishing points and the height
line in the picture plane (plan) to locate them on the horizon line.
(See Figs. 28 and 29 for an explanation of the horizon line.)

Step 9. Locate the ground line at the required distance below the
horizon line. (See Figs. 30 and 31 for an explanation of the
ground line.)

The next step is to draw the perspective view of the object. Once
the set-up has been completed (steps 1 to 9), the actual drawing is
done using visual rays, vertical projections and perspective lines,

35a Two-point perspective drawing: step 10.

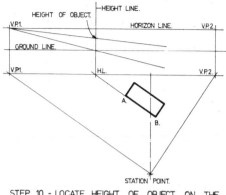

STEP 10. - LOCATE HEIGHT OF OBJECT ON THE HEIGHT LINE AND TOP AND BOTTOM LINES OF SIDE A-B IN THE PERSPECTIVE VIEW.

i.e. lines to the vanishing points, in the sequence shown in Fig. 35.

Opinions may vary as to the sequence used in the drawing of the perspective view. Any sequence can be used; for instance, some people prefer to locate the base of the object in the perspective view first. But whichever sequence is adopted the student is advised to follow it and only deviate from it when absolutely necessary, otherwise he can easily become confused in the early stages of his studies in perspective drawing. Many needless, time-consuming mistakes in perspective drawing are made because the wrong line or point is used. The student is advised to name each line clearly as soon as it is located. Similarly, as each point is located it should be identified so that it can easily be followed through the construction, and any mistakes quickly found and rectified.

Step 10. It is usually advisable to draw first the perspective view of the side of the object which is used to obtain the height line. To do this it is necessary to locate the height of the object on the height line. From the elevations the height of the object can be measured. Measuring from the ground up, the height of the object is located on the height line. From vanishing point 1 a line is drawn through the intersection of the height line and the ground line. The bottom line of the side of the object which was projected back to find the height line will be located on this line. (See Fig. 27.) From vanishing point 1 a second line is drawn through the measurement of the height of the object on the height line. The top line of the side of the object which was used to locate the height line will be located on this line.

35b Two-point perspective drawing: steps 11 and 12.

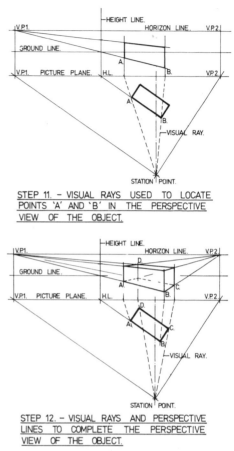

STEP 11. – VISUAL RAYS USED TO LOCATE POINTS 'A' AND 'B' IN THE PERSPECTIVE VIEW OF THE OBJECT.

STEP 12. – VISUAL RAYS AND PERSPECTIVE LINES TO COMPLETE THE PERSPECTIVE VIEW OF THE OBJECT.

Step 11. From the station point visual rays are drawn through the points of the object, i.e. the ends of the side used to find the height line, to meet the picture plane. From the points where these visual rays meet the picture plane, vertical lines are projected up to the lines representing the top and bottom lines of the side in perspective. With the location of the vertical lines at each end of the side of the object in perspective the side can be drawn as it will appear to a spectator looking at the object from the selected station point.

Step 12. By drawing the visual rays from the station point through the remaining points of the object and projecting up vertical lines from the points where they meet the picture plane the drawing of the object in perspective can be completed. From the diagram it can be seen that vanishing point 2 is used for the sides at right angles to the side drawn first. Vanishing point 1 is used

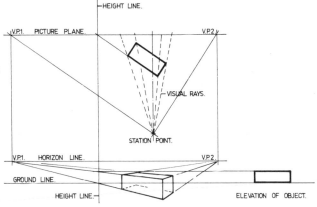

36 An alternative method of setting up a perspective construction and drawing.

for the side parallel to the side drawn first. It will be seen from the diagram that the point at the back of the object need not be sighted (that is to say, the visual ray need not be drawn) as this point can be located by drawing lines back to the vanishing points from the established sides of the object. However, it is often advisable to sight this point when accuracy is required.

The method shown here (Figs. 34 and 35) is considered the easiest and most convenient but in some cases, e.g. objects with a very complex elevation, it is preferable to place the plan as shown in Fig. 36 and to project directly across to the height line. As can be seen, the result is exactly the same as for the previous method.

The horizon is placed below the plan (as in the preceding method, any location can be used so long as it is directly above or below the plan of the picture plane.) The construction is identical to that shown in Fig. 34. When the ground line has been located an elevation is then set up (on whichever side is the more convenient) so that its ground line coincides with the ground line in the perspective construction.

The height of the object is located on the height line simply by projecting a horizontal line across from the top line of the elevation of the object to intersect the height line. The perspective view of the object can now be drawn as shown in Fig. 35b.

One-point perspective

The second of the more commonly used types of perspective drawing is the one-point perspective. In a number of ways one-point perspective is easier and quicker than the two-point but the principles are very much the same. The principles explained in Figs. 13 to 21 apply 41

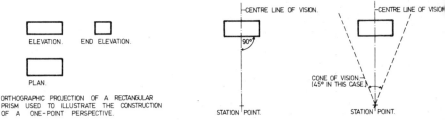

ELEVATION. END ELEVATION.

PLAN.

ORTHOGRAPHIC PROJECTION OF A RECTANGULAR
PRISM USED TO ILLUSTRATE THE CONSTRUCTION
OF A ONE-POINT PERSPECTIVE.

STEP 1. – OBTAIN INFORMATION.

STEP 2. – LOCATE STATION POINT
AND THE CENTRE LINE OF VISION
AT 90° TO A SIDE OF THE OBJECT.

STEP 3. – CHECK THE S.P.
WITH THE CONE OF VISION

37a One-point perspective
drawing: steps 1-3.

to one-point perspective even though the more common two-point
perspective has been used to illustrate them. The main differences
between the two types of perspective are in the selection of the
station point and, because of this difference, in the number of
vanishing points required by each.

In two-point perspective the station point is positioned so that
the centre line of vision is at an angle to a side of the object, so that
all four sides of a rectangular prism are at an angle to the spectator.
This means that two vanishing points will be required to draw the
object in perspective from this station point.

In one-point perspective, on the other hand, the station point is
located so that the centre line of vision is at right angles to a side
of the object. This means that this side and all lines parallel to it
will be parallel to the picture plane, therefore they will remain
parallel in the perspective drawing, and not converge to a vanishing
point. In the rectangular prism used to explain the method of draw-
ing an object in one-point perspective, the sides parallel to the pic-
ture plane are at right angles to the centre line of vision. In this
case the centre line of vision is a sight line parallel to a side of the
object, therefore the vanishing point for these sides parallel to the
sight line will be located at the intersection of this sight line and
the picture plane (plan). (See Figs. 23 and 24, *Vanishing Points.*)

A height line as such is not required in one-point perspective.
The method used for locating the height line in two-point perspec-
tive (Fig. 27) can be applied in one-point perspective but when
the sides of the rectangular prism used here are projected (back, in
this case) to meet the picture plane it is possible to link up the
points projected back and produce a true elevation of the object.

Once this particular aspect of one-point perspective is fully
understood it can be used to save a considerable amount of time and
effort. This is discussed further in the section dealing with interior
perspective, where it is shown to be a distinct advantage to locate a
side of the object in the picture plane so that one wall of the interior
can be drawn in the perspective as a true elevation.

STEP 4. - LOCATE THE PICTURE PLANE AT 90° TO THE CENTRE LINE OF VISION.

STEP 5. - LOCATE THE VANISHING POINT FOR THE SIDES OF THE OBJECT PARALLEL TO THE CENTRE LINE OF VISION. (SIGHT LINE.)

37*b* One-point perspective drawing: steps 4 and 5.

The method used for setting up a one-point perspective is shown in Fig. 37, and again it is emphasized that if the set-up is done in sequence it will be found easy to follow.

Step 1. Either obtain or prepare information regarding the object, i.e. plan, elevations and, if necessary, sections. For the purposes of illustration the same rectangular prism is used as for the preceding explanations and the two-point perspective.

Step 2. Select the direction of the view and the station point, i.e. the centre line of vision and the position from which it is proposed to view the object. In one-point perspective the centre line of vision will be at right angles to one of the sides of the object. As with two-point perspective, the centre line of vision is always drawn as a vertical line, so it is necessary to rotate the plan and the station point until the centre line of vision is vertical.

Step 3. The location of the station point should be checked at this stage with the cone of vision. (The cone of vision suggested in the earlier explanations was 45°.) If the whole of the object intended to be included in the drawing falls within this cone of vision, the position of the station point can be taken as confirmed. If not, it will be necessary to move the station point further back from the object. (It is not sufficient to simply widen the cone of vision; see Figs.16-18, *Cone of Vision.*)

Step 4. Locate the picture plane in the desired position. The picture plane is always drawn at 90° to the centre line of vision. (See Figs. 19-22 for an explanation of the picture plane.)

Step 5. Locate the vanishing point required for the perspective drawing of this object from this station point. As previously described, the centre line of vision is used as the sight line parallel to the sides of the plan of the object. Where this sight line and the picture plane intersect is the vanishing point for all lines parallel to the

43

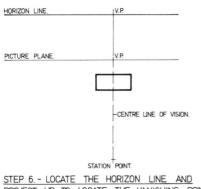

STEP 6. - LOCATE THE HORIZON LINE AND PROJECT UP TO LOCATE THE VANISHING POINT ON THE HORIZON LINE.

STEP 7. - LOCATE THE GROUND LINE.

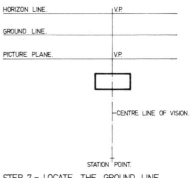

STEP 8. - LOCATE TRUE ELEVATION OF OBJECT ON ELEVATION OF PICTURE PLANE.

37c One-point perspective drawing: steps 6-8.

centre line of vision, i.e. all lines at right angles to the picture plane (See Figs. 24 and 25 for an explanation of the vanishing point.)

Step 6. Locate the horizon line in a convenient position either above or below the plan. In this example it is intended to draw the perspective view above the plan, so the horizon line is drawn at a convenient height above the picture plane. Project up from the plan the position of the vanishing point in the picture plane (plan) to locate it on the horizon line. (See Figs. 28 and 29 for an explanation of the horizon line.)

Step 7. Locate the ground line at the required distance below the horizon line. (See Figs. 30 and 31 for an explanation of the ground line.)

Step 8. No height line as such is required in one-point perspective but it is necessary to locate the elevation of the object on the elevation of the picture plane. The simplest method of doing this is

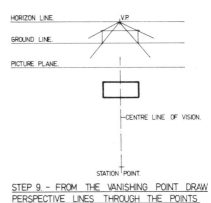

HORIZON LINE.

V.P.

GROUND LINE.

PICTURE PLANE.

CENTRE LINE OF VISION.

STATION POINT.

38*a* One-point perspective drawing: step 9.

STEP 9. – FROM THE VANISHING POINT DRAW PERSPECTIVE LINES THROUGH THE POINTS OF THE ELEVATION.

to project up from the plan, as shown in the diagram. The height of the object can be measured on the elevation and located on the elevation of the picture plane (measurement is set out from the ground line up). From this measurement the top line of the object can be drawn, thus completing the elevation of the object.

The next step is to draw the perspective view of the object. Once the set-up has been completed (steps 1 to 8), the actual drawing is done using visual rays, vertical projections and perspective lines, i.e. lines to the vanishing point.

Fig. 38 shows the sequence used for drawing the perspective view of the object, and if this or any other logical sequence is followed, time and wasted effort can be minimized. In one-point perspective, as in the two-point method, lines and points should be identified and named as soon as they are located. Acquiring this habit from the beginning will eliminate many of the time-consuming mistakes which, more often than not, are the result of using the wrong line or point.

Step 9. It is usually advisable to draw first the perspective lines of the object, i.e. lines from the vanishing point through the points of the elevation of the object on the picture plane. It will be on these lines that the lines of the object which are at right angles to the picture plane will be located.

Step 10. From the station point visual rays are drawn through the points of the front face of the object, i.e. the ends of the front face, to meet the picture plane. From the points where the visual

45

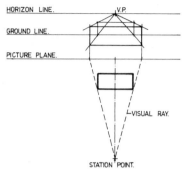

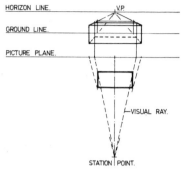

STEP 10.- VISUAL RAYS USED TO LOCATE THE FRONT FACE OF THE OBJECT IN THE PERSPECTIVE VIEW.

STEP 11. - VISUAL RAYS USED TO LOCATE THE REAR FACE OF THE OBJECT IN THE PERSPECTIVE VIEW.

38*b* One-point perspective drawing: steps 10 and 11.

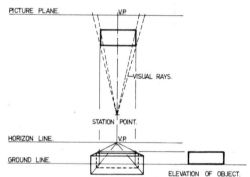

39 One-point perspective drawing: an alternative method of setting up.

rays meet the picture plane vertical lines are projected up to the lines representing the top and bottom lines of the ends of the object in perspective (the perspective lines located in step 9). Horizontal lines are drawn from the points of intersection and result in the outline of the front face of the object in the perspective drawing.

Step 11. By drawing visual rays from the station point through the two remaining points of the plan of the object (rear face) and projecting up vertical lines from the points where they meet the picture plane, the drawing of the object in perspective can be completed.

The method shown in Figs. 37 and 38 is considered the easiest and most convenient, but in some cases, e.g. objects having a very complex elevation, it is preferable to place the plan as shown in Fig. 39

46

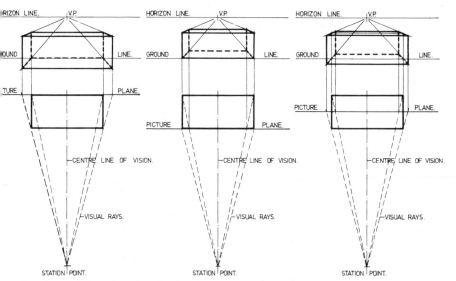

40 Three different locations for the picture plane, with fixed positions for the object and the station point.

and project directly across to the elevation of the object on the picture plane. In this method, the horizon line is placed below the plan (as in the previous method any location can be used so long as it is directly above or below the picture plane). The construction is identical to that shown in Fig. 37. When the ground line has been located an elevation is then set up (on whichever side is more convenient) so that its ground line coincides with the ground line in the perspective construction. The height of the object is located in the perspective view by projecting a horizontal line across from the top line of the elevation of the object. The perspective view of the object can now be drawn as described in Fig. 38. As can be seen, the result is exactly the same as for the previous method.

Fig. 40 shows three examples of one-point perspective drawings resulting from three different locations for the picture plane. As with two-point perspective, only the size of the perspective is affected by moving the picture plane; the view of the object remains the same. (The greater the distance between the station point and the picture plane the larger the resulting perspective drawing and, naturally, the smaller the distance the smaller the perspective drawing.)

The location of the picture plane is a matter of choice, convenience or regulation of the size of the perspective drawing. The three positions for the location of the picture plane shown in the diagram either coincide with a face of the object or pass through it. It will be 47

seen that the relationship of the plan of the object to the picture plane is maintained in the relationship of the perspective view and the ground line: that is to say, if the plan of the object is in front of the picture plane the perspective drawing of the object will be in front of the ground line, and vice versa. An understanding of this will help in setting up a perspective drawing because it will enable the student to locate the horizon line and the ground line in such a position as to allow enough room for the perspective drawing to be done without overlapping work already completed.

One-point and two-point perspective constructions combined

One-point and two-point perspectives are each treated as a separate type of perspective drawing but, as can be seen from the examples and explanations so far, they are based on exactly the same principles and are in fact interchangeable in a sense. The only difference between the two types is the angle of the centre line of vision to the side of the object at which the spectator is looking. Fig. 41 shows a spectator looking at two objects, one of which is parallel to the picture plane and will be drawn in one-point perspective. The other object is at an angle to the picture plane, so it will be drawn in two-point perspective. The station point, the centre line of vision and the picture plane are common to both objects, so that if each object is treated separately – the object parallel to the picture plane being drawn first as a one-point perspective and then the object at an angle to the picture plane as a two-point perspective – the resulting combination will show each object as the spectator would see it and each object will be in its correct relation to the other.

When producing a drawing containing more than one object or one set of vanishing points it is advisable to work on one object or one set of vanishing points at a time, to avoid confusion.

That one-point and two-point perspectives can be combined in one drawing is important because it allows for a wide variety of drawings which can be simply and quickly set up without the long and laborious sets of projections that are sometimes necessary to obtain the same results if only one type of perspective construction is used.

Fig. 42 shows another perspective view containing both one-point and two-point perspective constructions. In this example one object is located inside the other. The larger object is placed parallel to the picture plane and is therefore drawn as a one-point perspective. The

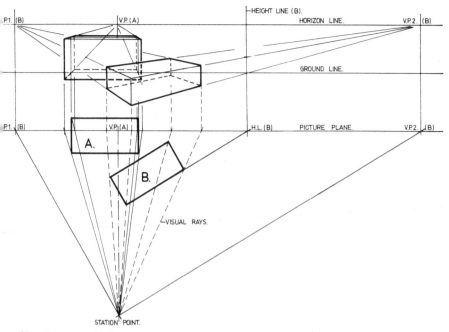

41 Set-up combining one-point and two-point perspective construction.

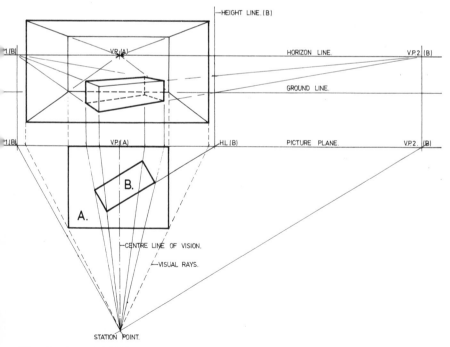

42 Another combination: two-point perspective inside a one-point perspective.

smaller object, which is positioned inside the larger one, is located at an angle to the picture plane, therefore it will be drawn as a two-point perspective. From this example it can be seen that this combination is very useful when working on interior perspectives of rooms etc.

Interior perspectives using one-point construction

Interior perspectives can be either one-point or two-point perspectives and in many cases both are used in one drawing, but it is usually the one used to set up the room which is the main construction that identifies the type of perspective used. The selection of a one-point or a two-point perspective for a specific drawing is often a matter of personal choice but it should be understood that while both types are accurate, one-point interiors are usually quicker and easier to set up and draw. This aspect can be only partly appreciated at this stage but it should become clearer as the student becomes more proficient at drawing perspective views of objects.

Another reason for the popularity of the one-point perspective for interior views is that it is easier to 'control', which means that there is less likelihood of unfortunate angles 'appearing' and other mistakes or accidents occurring which may not become evident in a two-point perspective construction until the drawing is well advanced. As with most things, experience is important in perspective drawing when it comes to controlling what is likely to happen; time spent in the beginning of a project 'controlling' as much as possible is seldom wasted.

Fig. 43 shows the set-up and perspective view of a simple room. To avoid confusion, it is shown without furniture or any details such as skirtings, architraves or light fittings. The method used for setting up the perspective view of the room is exactly the same as for any other one-point perspective but in this case the station point is located within the object to be drawn, which means that the wall behind the spectator will not be visible to him and therefore it will not appear in the perspective view.

It will be found that the use of the maximum angle for the cone of vision (60°) is advisable in interior perspectives, particularly of small rooms, because the recommended small angles (30°-45°) will be found much too restricting.

Once the main room is set up in the perspective view it is necessary to locate the positions of the door and the window. Because

43 A simple one-point interior perspective set-up and drawing.

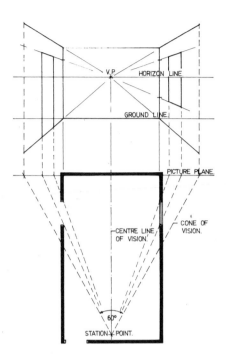

the end wall of the room coincides with the picture plane it is drawn in the perspective view as a true elevation, which means that measurements can be made on it using the same scale as that used for the plan. As the height of the door in the left-hand wall and the height of the top and bottom lines of the window in the right-hand wall are known (obtained from the plan, elevations and sections of the room, not shown here) they can be measured on the end wall. Because the door is in the left-hand wall (at right angles to the picture plane) it will be necessary to locate the measurement on the left-hand end of the end wall to allow this height to be projected back along the left-hand wall. The top line of the door will be located on this line. To locate the door it is necessary to sight its position in the plan in the usual fashion. (From the station point draw a visual ray through the sides of the door and from the points of intersection of these visual rays and the picture plane project vertical lines up to the wall in the perspective view. Using these vertical lines and the perspective line at the height of the top of the door, the actual door can be drawn in the perspective view.)

The window in the right-hand wall is located and drawn in the same way as the door. In this case, the height of the top and bottom lines of the window are set out on the right-hand end of the wall to allow for these heights to be projected back along the right-hand 51

wall. The actual position of the window in the perspective view of the wall is located using visual rays as before.

This example is kept simple to avoid confusion, but to include more detail would only mean repeating the procedures a greater number of times. The measurements of heights on the walls, irrespective of the reasons for them, are located in the same way as described and the locations of any features shown on the plan are sighted in the normal way, so that regardless of the complexity of the interior the method remains the same.

The location of a point in perspective

There are a number of different methods which can be used to locate a single point in perspective. Whichever method is used it should be understood that the principles are basically the same for each of them, and the variations are mainly in the way in which the point is related to its surroundings, e.g. picture plane, walls etc.

Three different methods are shown in Figs. 44-47 and it can be seen in each diagram that two lines are used to relate the point either to the picture plane or, as in Fig. 47, to two walls of the room in which the point is situated. Two lines are required to locate a point in perspective with the point situated at the intersection. These lines are located in plan, which means that they can be drawn in perspective thus locating the point at their intersection in the perspective view.

Figs. 44–47 show methods of locating points in perspective related to a one-point interior perspective, because it is in this type of perspective that it is usually required, e.g. for locating light fittings on ceilings. However, it will be seen on examining the diagrams that with the exception of Fig. 47 the points are related only to the picture plane, so they use the same picture plane as the main perspective but are in no other way related to the main perspective construction. In other words, the method of locating a point in perspective requires the point (or points) to be located in plan in relation to the station point, the centre line of vision and the picture plane, and regardless of what is going on around this plan the set-up of the position of the point can be plotted in perspective. Therefore these methods can be used for locating points in either one-point or two-point perspective constructions.

In Fig. 44, to locate point *A*, which is on the floor plane (ground plane):

44 The most usual method of locating a point in perspective (located on the floor plane).

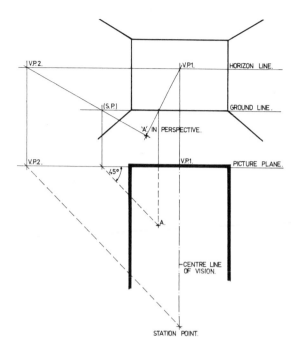

Step 1. From point *A* in the plan draw a line to meet the picture plane at 45° or any convenient angle.

Step 2. From the point of intersection of this line and the picture plane project up a vertical line to meet the ground line. (This point is sometimes known as the starting point.)

Step 3. Locate vanishing point 2 by drawing a sight line from the station point parallel to the line from point *A* to the picture plane. Where this sight line meets the picture plane is the plan position of vanishing point 2.

Step 4. Project up vertically from the plan position of vanishing point 2 to locate it on the horizon line.

Step 5. From point *A* in plan draw a line parallel to the centre line of vision to meet the picture plane (the end wall of the room in this case), and continue this line up to meet the ground line.

Point *A* in plan can be seen in the diagram to be located at the intersection of the two lines – one at 45° to the picture plane and the second parallel to the centre line of vision (at 90° to the picture plane).

Step 6. From vanishing point 2 through the starting point draw a line representing the perspective view of the line from point *A* to the picture plane, meeting it at 45° (in plan).

53

45 The method of locating a point in the ceiling plane in one-point perspective.

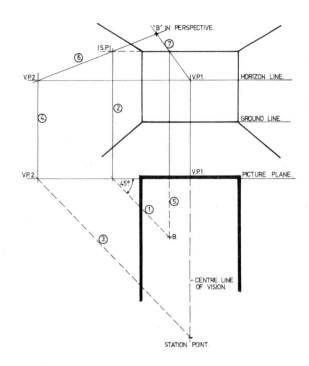

Step 7. Finally the perspective view of the line parallel to the centre line of vision (in plan) can be drawn using vanishing point 1.

When the point is located in the ceiling plane, as shown in Fig. 45, the same method is used as for a point in the floor plane (ground plane) except that instead of the ground line being used in steps 2 and 5 the ceiling line is used. In Fig. 45 the steps are numbered to tie in with the description of the method for point *A* in the floor plane.

The alternative method of locating a point in perspective shown in Fig. 46 is based on the preceding method but uses a visual ray instead of a line parallel to the centre line of vision. The seven steps for locating point *C* in perspective are:

Step 1. From point *C* draw a line to meet the picture plane at 45° (any convenient angle can be used). Where this line meets the picture plane is the point known as the starting point (s.p.).

Step 2. Locate the starting point on the ground line by projecting up vertically from the plan position of the starting point in the picture plane.

Step 3. From the station point draw a sight line parallel to the line from point *C* which meets the picture plane at 45°. The inter-

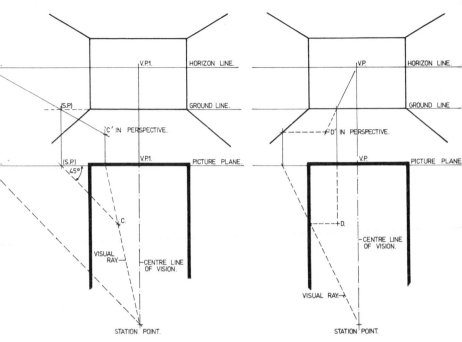

46 An alternative method of locating a point in perspective.

47 Another alternative method of locating a point in perspective.

section of the sight line and the picture plane is the location of vanishing point 2 in plan.

Step 4. Locate vanishing point 2 in the horizon line by projecting a line up vertically from its position in plan.

Step 5. From vanishing point 2 draw a line through the starting point and continue it as far as necessary.

Step 6. From the station point draw a visual ray through point C (in the plan) to meet the picture plane.

Step 7. From the point in the picture plane where the visual ray through point C meets it, project up a line to intersect the line from vanishing point 2 through the starting point. The point where these two lines intersect is the location of point C in perspective.

The third method of locating a point in perspective, shown in Fig. 47, is the quickest and simplest one when the point is within a shape or can be related to an object.

Step 1. From point D (in plan) draw a line parallel to the side wall of the room to meet the end wall (picture plane). From this point

on the end wall project up a vertical line to meet the ground line (point D is in the floor plane).

Step 2. From point D (in plan) draw another line, in this case parallel to the end wall (picture plane) to meet the side wall of the room.

Step 3. From the station point draw a visual ray through the point on the side wall where the line from point D meets it, to meet the picture plane. From the point on the picture plane where the visual ray meets it project up a vertical line to meet the floor line of the side wall in the perspective view of the room.

Step 4. The line drawn parallel to the side wall in the plan can be located in the perspective view by drawing a line from the vanishing point through the point in the ground line located in step 1.

Step 5. The line drawn parallel to the end wall in the plan can be located in the perspective view by drawing a line from the point in the floor line of the side wall (located in step 3) parallel to the end wall in the perspective view. Point D in perspective is located at the intersection of the two lines located in steps 4 and 5.

The location of a number of points in perspective

Fig. 48 shows the method used for locating more than one point (two points in this example) in perspective when the position of the station point, the centre line of vision, the picture plane and the height of the eye-level are given. The method is similar to the one used in Fig. 44 with one exception. Instead of using a line from the point in the plan to meet the picture plane at any convenient angle, a line is drawn through both points and continued on to meet the picture plane. A line parallel to this line is then used to locate the vanishing point. The rest of the construction to locate the two points is exactly the same as the one described in Fig. 44.

The location of a single line in perspective

The location of a single line in perspective is exactly the same procedure as that used to locate two points in perspective. Fig. 49 shows a short line GH in plan, with G corresponding to E in Fig. 48

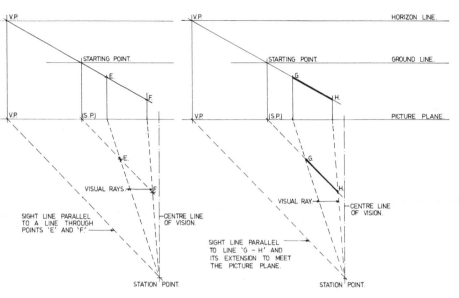

48 The method used to locate two points in perspective.

49 The method used to locate a single line in perspective.

and *H* corresponding to *F*. The ends of the line *GH* have been made to correspond with points *E* and *F* in Fig. 48. The same station point, picture plane and centre line of vision have been used, to show that the methods employed for locating two points in perspective and for locating a line in perspective are identical.

This method can be used to locate any line in perspective and is, in fact, the simple basis of all perspective drawing. By comparing the diagram with previous diagrams (Figs. 34–42) it will be seen that location of a line in perspective is the same whether the line is the object or only a part of an object.

Fig. 50 shows a method of locating and drawing a line in perspective when the line is situated above the ground plane. From this diagram it can be seen that the same plan is used whether the line is on the ground plane or above it. (The position of the line in perspective if it had been situated on the ground plane is shown dotted.)

The location of a height line is essential for this exercise. By reference to Figs. 26 and 27 it will be seen that the starting point is in fact the point on the picture plane where the height line and the ground line intersect. This means that the height line is located in this exercise simply by projecting a line up vertically from the starting point in the picture plane (plan). Once the height line has been located, the required height *h* of the line above the ground can be measured and a line drawn through it from the vanishing point. (The line *JK* will be located on this line.) When this line is drawn, the 57

50 The method used to locate a single line above the ground plane in perspective.

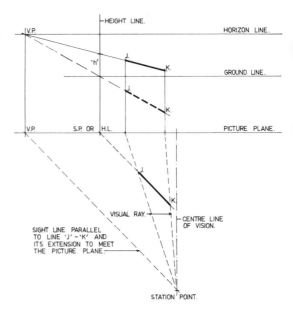

51 The method used to locate a number of lines in perspective when they are at different heights above the ground plane, and not parallel.

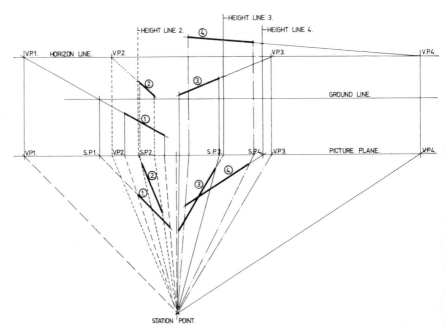

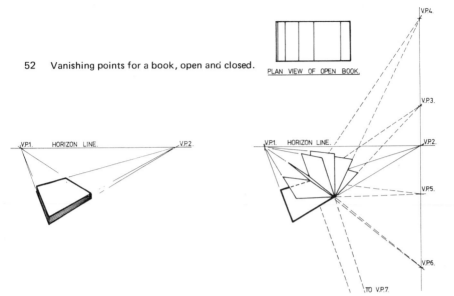

52 Vanishing points for a book, open and closed.

PLAN VIEW OF OPEN BOOK.

V.P1. HORIZON LINE. V.P2.

V.P4.

V.P3.

V.P1. HORIZON LINE. V.P2.

V.P5.

V.P6.

TO V.P7.

vertical lines from the points of intersection of the visual rays from the station point through the ends of the line in plan are projected up to meet this line, thus locating the length of the line in perspective.

The methods shown in Figs. 49 and 50 are used in Fig. 51 to locate and draw four lines in perspective. This diagram looks very complicated but in reality it is only the one method repeated four times with all the construction lines shown. Each separate line can be followed through from its position in the plan to its required position in the perspective. If each line is located and drawn before the next is considered, what looks like a complicated drawing is greatly simplified.

Inclined lines and planes in perspective

Up to this stage, only lines parallel to the ground plane have been considered. Many objects contain not only lines parallel to the ground plane (horizontal lines) and vertical lines but also lines inclined to the ground plane, so that it is necessary to locate vanishing points for these inclined lines.

Parallel lines which are inclined to both the picture plane and the ground plane will appear to converge to a vanishing point. The most important rule to remember when working with inclined lines and planes is that the vanishing point for inclined lines or an inclined plane is always directly above or below what its position would be if the lines or plane were in the horizontal plane. This can best be explained when applied to a book (see Fig. 52).

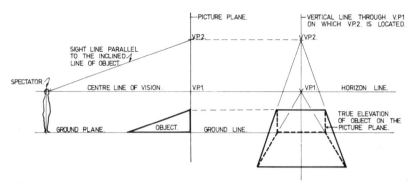

53 A spectator looking at an object which has inclined lines, and a view of the object as seen by him.

The book, when closed and placed on a horizontal plane, can be drawn as a simple rectangular prism. The locations of vanishing points 1 and 2 are found as previously described. These vanishing points are the vanishing points for the sides of the book and all lines parallel to them. This means that while the book remains closed these vanishing points will be the vanishing points for the individual pages of the book as well. When the book is opened and looked at in plan, the edges of the individual pages will remain parallel to the sides of the book because only the inclination of the pages is affected. This means that the vanishing points for the individual pages are located in plan in the usual way. (Draw a sight line from the station point parallel to a side of the object; the intersection of this line and the picture plane is the plan position of the vanishing point.) The vanishing point for the closed book and the individual open pages of the book in the plan construction having been established, it can be seen that the actual positions of the vanishing points for the open pages will fall in a vertical line through the vanishing point for the closed book, which will be in the horizon line.

It has been established previously that in all cases where a sight line parallel to a side or line of an object meets the picture plane, that point will be the vanishing point for that side or line of the object and all lines parallel to it. Therefore when drawing a perspective view of an object containing an inclined line or lines it is necessary to use a sight line parallel to the inclined line to locate its vanishing point on the picture plane. Fig. 53 shows a spectator looking at an object which includes inclined parallel lines. As previously described, the centre line of vision is a sight line and, because in this case the object is parallel to the picture plane (one-point perspective), the vanishing point for the lines of the object parallel to the ground plane will be located at the point where the sight line parallel to them meets the picture plane. Because the inclined lines of the object are

directly above the lines in the ground plane, the vanishing point for the inclined lines will be directly above the vanishing point for the lines in the horizontal plane (ground plane).

In the view of the object as seen by the spectator in Fig. 53 it can be seen that V.P.1 and V.P.2 are located in a vertical line, and the height of V.P.2 above V.P.1 is found by projecting across from the elevation where the sight line parallel to the inclined lines of the object meets the picture plane.

The location of the vanishing point for the inclined lines of the object can be checked simply by setting up the horizontal and vertical planes of the object (in this case, in one-point perspective). This means that the base of the object is drawn in the ground plane and the vertical plane of the object, which coincides with the picture plane, is drawn in true elevation. A line joining a front corner of the base of the object to the appropriate top corner of the vertical plane in the picture plane is continued until it meets a vertical line drawn through V.P.1 at V.P.2 (the vanishing point for the inclined lines of the object). This exercise can be repeated for the second inclined line of the object, and if the draughting is accurate it too will pass through V.P.2.

Fig. 55 shows an alternative method for locating vanishing points for inclined lines based on the method used here to check the position of the vanishing point located by using an elevation.

One-point perspective has been used to explain the principles of locating vanishing points for inclined lines, but, as can be seen from the diagram in Fig. 52, inclined lines occurring in objects drawn in two-point perspective also have their vanishing points located by using the same principles.

Location of vanishing points for inclined lines in two-point perspective

The method of locating the vanishing points for inclined lines in two-point perspective (Fig. 54) is based on the two-point perspective construction previously described in Figs. 34 and 35, and all the horizontal and vertical lines of the object are located and drawn in the perspective view in the normal way. The method of locating the vanishing points for the inclined lines of the object is as follows:

Step 1. It is first necessary to produce an elevation of the object in relation to the picture plane and the station point. The most

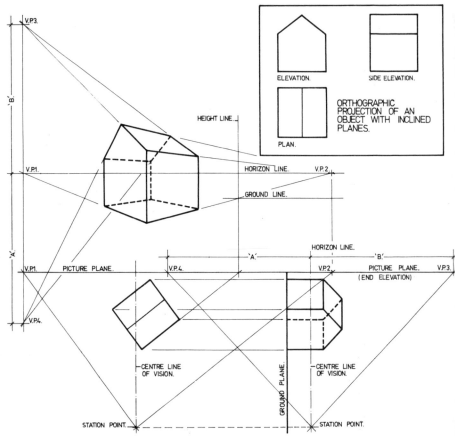

54 The method of locating the vanishing points
for inclined lines in two-point perspective.

convenient position for this elevation is as shown in the diagram
(beside the plan construction). A ground plane is drawn parallel
to the centre line of vision at a convenient distance from it, to
meet the picture plane at an angle of $90°$. The station point can
be located in the elevation by projecting across from the station
point in the plan position. The height of the eye level is known
and can therefore be measured to locate the centre line of vision,
which is drawn parallel to the ground plane. The elevation of the
object is drawn by projecting across from the plan and using
measurements obtained from the orthographic projection of the
object (heights). The elevation of the object produced shows the
true inclination of the inclined lines to the picture plane when
the object is placed in the position shown in plan.

62

Step 2. As previously described, a sight line from the station point
(in elevation) parallel to a line of the object will intersect the
picture plane at the vanishing point for that line in perspective.
Therefore, using the elevation produced in the preceding step,
the location of the vanishing points V.P.3 and V.P.4 for the
inclined lines of the object is a simple matter of drawing sight
lines from the station point parallel to the inclined lines of the
object to meet the picture plane. Where these sight lines meet
the picture plane at V.P.3 and V.P.4 their height above or
below the horizon line can be measured. In this case V.P.3 is a
distance B above the horizon line and V.P.4 is a distance A below
it.

Step 3. It has been established in Figs. 52 and 53 that the vanishing
point for inclined lines will be directly above or below the vanish-
ing point for the lines if they were in the horizontal plane. The
inclined lines of the object shown here are in the plane used to
locate V.P.1, so V.P.3 and V.P.4 will be located in a vertical line
drawn through V.P.1. V.P.3 will be located at a height B above
V.P.1, which is in the horizon line, and V.P.4 will be located at
a height A below V.P.1. V.P.3 and V.P.4 can now be used to draw
the inclined lines of the object in perspective as shown in the
diagram.

This method is considered the most accurate, but because it requires
the setting up of a special elevation the simpler and quicker alter-
native method is favoured by many. The alternative method is ade-
quate for most projects but its accuracy is often suspect because it
relies on the accuracy of the draughtsman to a much greater degree
than the method shown in Fig. 54.

Alternative method

Fig. 55 shows the same orthographic projection as used in Fig. 54,
but in this case a centre line has been drawn on the elevation with
the inclined lines, and a horizontal line has also been drawn forming
a triangle (this line is used here only for the purpose of explanation
and is not normally necessary when preparing a drawing). The
height of the object is measured in two parts as shown. The height
H from the ground to the lower end of the inclined line is measured
and the vertical difference h between the lower end and the higher

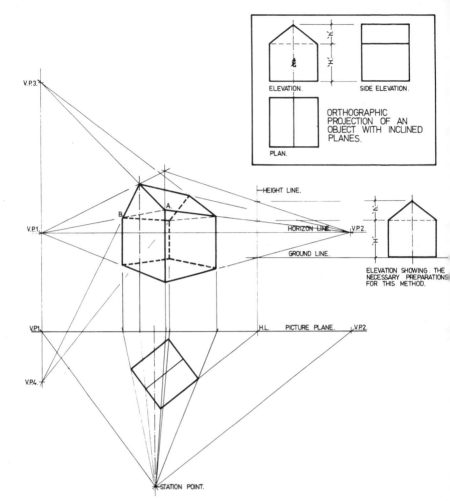

55　Alternative method of locating the vanishing
points for inclined lines in two-point perspective.

end of the inclined lines is also measured. These two dimensions
and the centre line are all the preparations needed to locate the vanish-
ing points for the inclined lines using this alternative method.

The method is based on the two-point construction previously
described in Figs. 34 and 35, and all the horizontal and vertical
lines of the object are located and drawn in the perspective view in
the normal way. The method of locating the vanishing points for
the inclined lines of the object is as follows:

Step 1.　It is first necessary to locate the line in perspective on
which the apex of the triangle formed by the inclined lines on
the elevation of the object and the horizontal line shown in
Fig. 55 will be located. Because, in this case, the apex of the

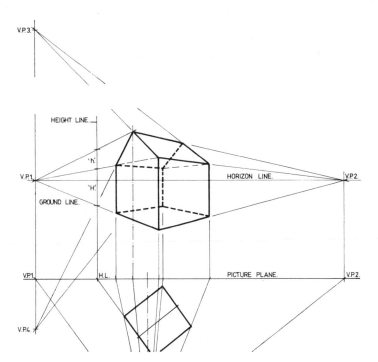

56 Inclined lines in two-point perspective: a
third method.

triangle also falls on the centre line of the building, this line
is located in the plan and projected up and located in the
perspective view in the normal way. Thus the apex of the triangle
in perspective is located at the intersection of these two lines.

Step 2. From the point marked *A* in the perspective a line is drawn
through the apex of the triangle (on the centre line) and con-
tinued to meet a vertical line drawn through V.P.1. Where these
two lines intersect (V.P.3) is the location of the vanishing point
for the inclined line used to locate it and all lines parallel to it.
(The vanishing point for an inclined line is located directly above
or below its position if the line were located in the horizontal
plane.)

Step 3. V.P.4 is found in a similar way to V.P.3; a line is drawn
from the apex of the triangle (on the centre line) through point
B and continued to meet the vertical line drawn through V.P.1
at V.P.4.

Using V.P.3 and V.P.4 it is possible to complete the drawing of
the object in perspective. From Fig. 55 it should be obvious to the
student that if a height line was located by projecting the side con-
taining the inclined lines, one set of projections could be eliminated, 65

thus reducing the possibility of further compounding any errors which may have been caused by inaccurate draughting. Fig. 56 shows the same alternative method as used in Fig. 55, with the height line located by projecting the side containing the inclined lines back to the picture plane. (Any convenient side may be projected backwards or forwards to meet the picture plane to locate a height line – see Fig. 26.) Apart from the different position of the height line, the drawing of the object in perspective is completed in the same way as in Fig. 55.

Location of vanishing points for inclined lines in one-point perspective

Inclined lines in one-point perspective are treated in much the same way as they are in two-point perspective. The diagram in Fig. 53 shows the basic principles of locating the vanishing points for inclined lines. Figs. 57 and 58 show the methods used for setting up a one-point perspective of an object including inclined lines.

When dealing with inclined lines in one-point perspective the first thing to remember is that parallel inclined lines which are located parallel to the picture plane remain parallel, i.e. they do not converge to a vanishing point. The usual method for drawing inclined lines which are parallel to the picture plane is shown in Fig. 57. The object (a simple ramp in this example) is located in a room which is drawn in one-point perspective, using the method described in Fig. 43; this means that the end wall of the room coincides with the picture plane and is drawn in true elevation in the perspective view. One side of the ramp coincides with the wall (itself coinciding with the picture plane), therefore a true elevation of the ramp can also be drawn in the perspective view.

The drawing of the ramp is completed by using the vanishing point to locate the bottom line of the ramp on the floor and its top line on the right-hand wall. The width of the ramp is located by drawing visual rays from the station point through the points of the plan of the object. From the intersections of the visual rays and the picture plane vertical lines are drawn up to the top and bottom lines of the ramp. From these intersections the side of the ramp nearest to the station point can be drawn.

From this example it can be seen that the sides of the object, whether horizontal, vertical or inclined, if located parallel to the picture plane in plan, remain parallel to each other in the perspec-

57 Inclined lines parallel to the picture plane in one-point perspective.

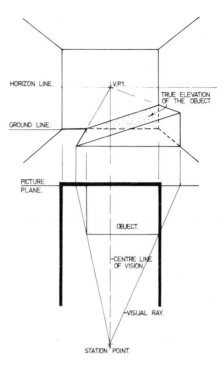

tive view. It can also be seen that any inclined line parallel to the picture plane can be located in the perspective view by drawing a true elevation of the inclined line on the picture plane and locating it by using simple projection.

When the same object is placed in the same room but turned round so that the sides containing the inclined lines are at right angles to the picture plane, as shown in Fig. 58, the inclined lines will recede from the spectator, and so a vanishing point will be required for them.

First, the room is set up as described in Fig. 43. When the drawing of the room in the perspective view is completed, the object can be located and drawn.

Step 1. Locate and draw the elevation of the side of the object, which coincides with the end wall of the room. (The end wall of the room coincides with the picture plane.) This is done by projecting up from the plan and measuring the height on the elevation of the object.

Step 2. The lines of the base of the object are located and drawn on the floor plane by projecting up from the intersections of visual rays and the picture plane together with lines from vanishing point 1.

67

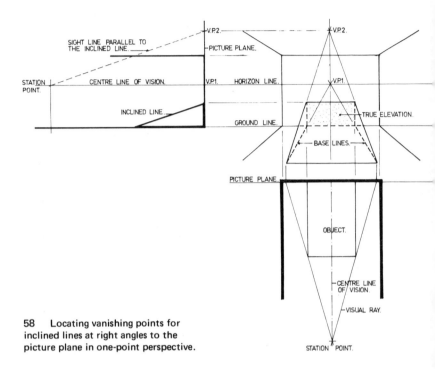

58 Locating vanishing points for inclined lines at right angles to the picture plane in one-point perspective.

Step 3. Draw an elevation showing the object in its position in relation to the picture plane, station point, ground line and eye level (horizon line). From the station point (eye) a sight line is drawn parallel to the inclined line of the object to meet the picture plane at vanishing point 2 (the vanishing point for the inclined lines and all lines parallel to them).

Step 4. From V.P.2 in the elevation, project across to meet a vertical line drawn through V.P.1. This point will be the vanishing point for the inclined lines in the perspective view. Using V.P.2, the inclined lines can be drawn in the perspective view as shown in Fig. 58.

An alternative method can be used to find the vanishing point for the inclined lines, but, like the alternative method for locating vanishing points for inclined lines in two-point perspective (Fig. 55), it is less accurate than the method shown in Fig. 58. When this alternative method is used, the room is set up exactly as in the previous method. Steps 1 and 2 are the same as those described in the previous method; it is only steps 3 and 4 which differ.

Step 3. Select one corner of the base of the object in the floor plane and from it draw a line through the appropriate top corner of the elevation of the object in the picture plane, and continue the line until it intersects a vertical line drawn through V.P.1. The point of intersection of these two lines is the vanishing point (V.P.2) for the inclined lines.

Step 4. From the other corner of the base of the object in the floor plane a line is drawn through the appropriate top corner of the elevation of the object (in the picture plane) and continued to meet the vertical line through V.P.1 at V.P.2.

This method relies on the accuracy of the draughtsman, and if care is taken it is considered sufficiently accurate for most requirements. But if extreme accuracy is needed, the student is recommended to use the first method described here.

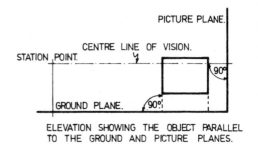

ELEVATION SHOWING THE OBJECT PARALLEL
TO THE GROUND AND PICTURE PLANES.

59 Comparison between the
plan used for one-point and two-
point constructions (i.e. vertical
lines parallel to the picture plane)
and the 'special' plan required for
three-point perspective.

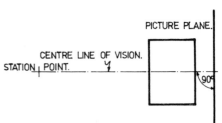

PLAN SHOWING THE OBJECT PARALLEL
TO THE GROUND AND PICTURE PLANES.

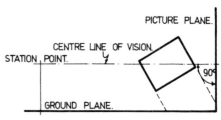

ELEVATION SHOWING THE OBJECT INCLINED
TO THE GROUND AND PICTURE PLANES.

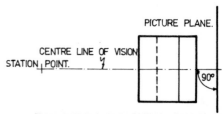

PLAN SHOWING THE OBJECT INCLINED TO
THE GROUND AND PICTURE PLANES.

3 Three-point perspective: objects inclined to the ground plane

In the previous examples of perspective, only those requiring one or two vanishing points have been used. Some aspects of these constructions have required extra vanishing points to help in the execution of the drawing, but the constructions have been based on either one-point or two-point constructions.

In these constructions it will be seen that the vertical lines of a rectangular prism, when parallel to the picture plane, i.e. at 90° to the ground plane, will be vertical in the perspective drawing. When the rectangular prism is inclined to the ground plane, however, these lines will no longer remain vertical in the perspective drawing, therefore they will have to be treated as inclined lines. This means that a vanishing point will be required for these lines which, in one-point and two-point constructions, were vertical. The addition of this vanishing point, which is known as the vertical vanishing point (V.P.3), is the reason for the name 'three-point perspective'.

The vertical vanishing point is located either directly above or directly below the intersection of the centre line of vision and the picture plane (on the horizon line). As previously described, the vanishing points for inclined lines will be directly above or below what would be the vanishing points for these lines if they were in the horizontal plane. The lines of the object which were vertical when the object was parallel to the ground plane will be visible when the object is inclined, and will appear as lines parallel to the centre line of vision (at right angles to the picture plane). Therefore, because the centre line of vision is considered as a sight line parallel to the sides of the object (in plan), the vanishing point for these inclined lines of the object will be located either directly above or directly below the intersection of the centre line of vision and the picture plane.

Fig. 59 shows the object in its normal position, i.e. located with its vertical lines parallel to the picture plane, so that it can be drawn in one-point perspective. Also shown in Fig. 59 is the object inclined to the ground plane, i.e. located with its vertical lines

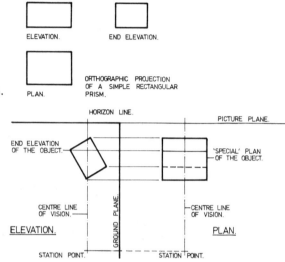

60 The method used for preparing a 'special' plan for a three-point perspective construction (when the object is inclined to the ground plane) based on a one-point construction. For the method based on a two-point construction, see Fig. 65.

inclined to the picture plane, which means that a vertical vanishing point will be required before it can be drawn in perspective.

From the diagram in Fig. 59 it will be seen that, because the object is inclined, the lines which were vertical in one-point and two-point constructions will now be visible in the plan view of the object. This means that a 'special' plan must be prepared for three-point perspective. Using, as before, a simple rectangular prism for our example (see Fig. 60), the first step is the selection of the station point, the eye level and the picture plane in relation to the object. These are drawn in elevation, as shown in the diagram. The end elevation of the object is located and drawn at the required angle to the ground and picture planes.

From the elevation, horizontal lines are projected across to a convenient location where the plan view of the inclined object can be drawn together with the plan views of the picture plane, the station point and the centre line of vision. (The length of the object is measured on the orthographic projection.)

Only the vertical lines have been considered so far, but it should be remembered that not only the 'vertical' lines become inclined lines when the object is inclined to the ground plane. In the example shown in Figs. 59 and 60 the lines which were parallel to the centre line of vision (horizontal lines at right angles to the picture plane) will become inclined lines when the object is inclined to the ground plane.

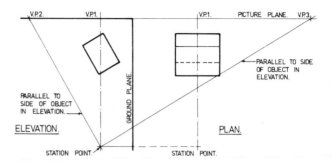

61*a* Setting up a three-point perspective based on a one-point construction: step 1.

ELEVATION.

PARALLEL TO SIDE OF OBJECT IN ELEVATION.

GROUND PLANE.

PLAN.

PARALLEL TO SIDE OF OBJECT IN ELEVATION.

V.P.2. V.P.1. V.P.1. PICTURE PLANE. V.P.3.

STATION POINT. STATION POINT.

STEP 1. – LOCATE VANISHING POINTS FOR THE INCLINED LINES
OF THE OBJECT USING THE ELEVATION.

From this information and the diagram it can be seen that three-point perspective is an exercise in the setting up of inclined lines. There are two methods of setting up three-point perspectives, one based on the one-point and the other on the two-point construction. If the lines of the object are parallel to the picture plane *or* the centre line of vision in the plan view, a basic one-point construction is used; if these lines are at an angle to the picture plane *and* the centre line of vision in the plan view, a basic two-point construction is used.

The first method explained here is the one based on the one-point construction, and it continues from Figs. 59 and 60. Having prepared a 'special' plan as described in Fig. 60, the location of the station point should be checked with the cone of vision and adjusted if necessary.

The method of setting up a three-point perspective based on a one-point construction is as follows:

Step 1. Locate the vanishing points for the inclined lines. As previously described, the vanishing point V.P.1 for lines parallel to the centre line of vision is located at the point where the centre line of vision meets the picture plane. This means that the vanishing points for inclined lines parallel to the centre line of vision in the plan view will be in a vertical line through V.P.1. The heights of these vanishing points above or below the horizon line (V.P.1) are located by drawing sight lines parallel to the inclined lines of the object in the elevation. The points where these sight lines intersect the picture plane are the locations of the heights of the vanishing points for the inclined lines. These heights are located on the elevation, and even though they may overlap the plan construction (as they

73

61*b* Setting up a three-point perspective based on a one-point construction: step 2.

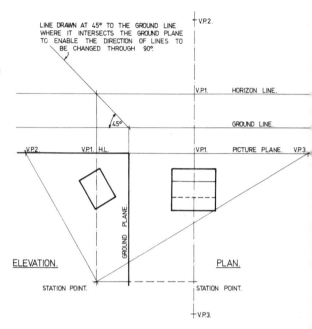

LINE DRAWN AT 45° TO THE GROUND LINE WHERE IT INTERSECTS THE GROUND PLANE TO ENABLE THE DIRECTION OF LINES TO BE CHANGED THROUGH 90°.

V.P.2.

V.P.1. HORIZON LINE.

45° GROUND LINE.

V.P.2. V.P.1. H.L. V.P.1. PICTURE PLANE. V.P.3.

GROUND PLANE.

ELEVATION. PLAN.

STATION POINT. STATION POINT.

V.P.3.

STEP 2. – LOCATE THE GROUND LINE AND THE HORIZON LINE TOGETHER WITH A LINE AT 45° TO THE GROUND LINE TO ENABLE THE DIRECTION OF LINES TO BE CHANGED THROUGH 90°. (V.P.2 AND V.P.3 ARE LOCATED ON A VERTICAL LINE DRAWN THROUGH V.P.1.)

do in the example shown here), it should be remembered that all dimensions are measured from the horizon line in the elevation. The vanishing point V.P.2 for the lines which were horizontal when the object was placed on the ground plane (see Fig. 59) is located above the horizon line when the object is inclined to the ground plane and looked at from above. The vanishing point V.P.3 for the lines which were vertical when the object was placed on the ground plane is located below the horizon line when the object is inclined to the ground plane and looked at from above.

Step 2. The horizon line is located in a convenient position, as previously described, and the ground line is located below it in the usual way (the distance between the horizon line and the ground line being the height of the eye level, as required). The elevation of the ground plane is extended to meet the ground line (on the elevation of the picture plane where the perspective view is to be drawn) as shown in Fig. 61*b*. From the intersection of the ground plane (in the elevation) and the ground line a line is drawn at 45° to the ground line. This line is used to

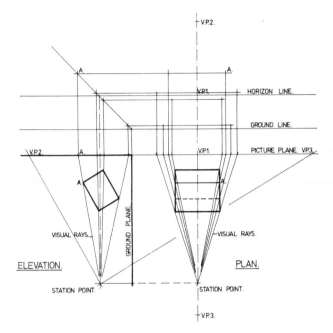

62*a* Setting up a three-point perspective based on a one-point construction: step 3.

STEP 3. – VISUAL RAYS AND PROJECTIONS USED TO LOCATE THE POINTS OF THE OBJECT IN THE PERSPECTIVE VIEW.

change the direction of lines through 90°. This construction makes use of the fact that if the centre line of vision in the elevation is extended it will meet the horizon line at the point where it intersects the line drawn at 45° to the ground line (where the centre line of vision meets the end elevation of the picture plane is the horizon line, as already explained). From this it will be seen that the ground line and the horizon line, though they change direction through 90°, remain parallel and therefore the same distance apart.

V.P.2 is located on a vertical line drawn through V.P.1 and its height above V.P.1 can be measured on the elevation. V.P.3 is located on a vertical line drawn through V.P.1 and its height below V.P.1 can also be measured on the elevation.

Step 3. Visual rays are used to locate the points of the object on the picture plane in the usual way. These visual rays are required not only on the plan but also in the elevation, as shown in Fig. 62*a*. The best way to understand the construction required to locate a point of the object is to 'follow' one selected point. From the station point in the plan a

62b Setting up a three-point perspective based on a one-point construction: step 4.

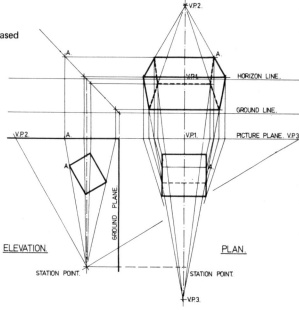

STEP 4. – VANISHING POINTS (V.P.2 AND V.P.3.) ARE USED TO DRAW THE PERSPECTIVE VIEW OF THE OBJECT.

visual ray is drawn through a selected point A of the object to meet the picture plane, and from this point on the picture plane a vertical line is projected up in the normal way. Point A is located in the end elevation of the object and a visual ray from the station point is drawn through point A to meet the end elevation of the picture plane. From this point on the end elevation of the picture plane a vertical line is projected up to meet the line drawn at 45° to the ground line. From this point a horizontal line is projected across to meet the vertical line located in the plan by projecting up from the point on the picture plane where the visual ray drawn through point A meets it. Point A in the perspective view is located at the intersection of the vertical line from the plan and the horizontal line from the elevation. The other seven points of the object are located in the perspective view in the same way.

Step 4. The object is drawn in the perspective view by identifying the points of the object and drawing the outline with the help of V.P.2 and V.P.3. Care should be exercised when identifying the points of the object; it is often advisable to follow the practice

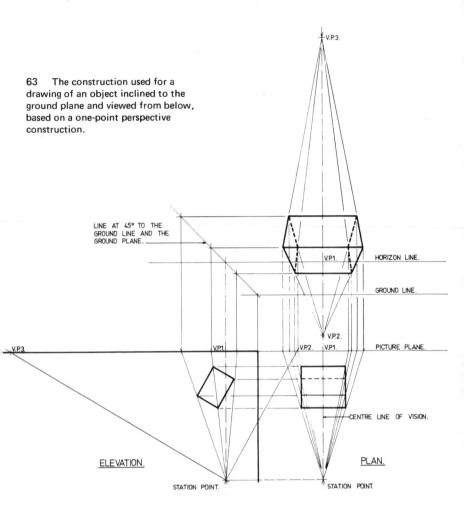

63 The construction used for a drawing of an object inclined to the ground plane and viewed from below, based on a one-point perspective construction.

LINE AT 45° TO THE GROUND LINE AND THE GROUND PLANE.

V.P.3.

V.P.1.

V.P.2.

HORIZON LINE.

GROUND LINE.

PICTURE PLANE.

CENTRE LINE OF VISION.

ELEVATION.

PLAN.

STATION POINT.

STATION POINT.

shown here of identifying each point where it occurs in each step. In this way points do not 'get lost', causing delays and frustration as well as unnecessary work in repeating steps to try and find mistakes.

The example shown in Figs. 59–62 is based on an object inclined so that its top is visible to the spectator, and it is therefore referred to as an object viewed from above. Fig. 63 shows the same object inclined so that the bottom is visible to the spectator, and it is thus referred to as an object viewed from below.

The method used to draw an object inclined to the ground plane so that it is viewed from below, based on a one-point perspective construction, is the same as that used for the preceding example when the object is viewed from above. Only the locations of the

77

vanishing points are changed, i.e. V.P.2 is below the horizon line and V.P.3 is above it.

The second, and probably the commonest, type of three-point perspective is the one based on a two-point construction. The principles remain the same whether a three-point perspective is based on a one-point or a two-point construction, so it is not necessary to repeat those principles here.

Like three-point perspectives based on one-point constructions, one based on a two-point construction requires a 'special' plan showing the object inclined to the ground plane. Fig. 64 shows the orthographic projection of an object (a rectangular prism) used to illustrate the method of setting up a perspective view of the object inclined to the ground plane when a three-point perspective based on a two-point construction is needed.

As with other methods, it is necessary first to locate the station point and the centre line of vision. When the direction of the view of the object is decided it is necessary to rotate the plan until the centre line of vision is *horizontal* (Fig. 64, top right). The elevation of the object at right angles to the centre line of vision can then be drawn using projections from the elevation in the orthographic projection (to obtain the height) and from the plan.

The prepared elevation is set up (Fig. 64, centre right) so that the picture plane is horizontal and a ground plane is drawn at right angles to it. The prepared elevation is drawn at the required angle to the ground plane and the picture plane. The station point is then located in the elevation and the height of the eye above the ground is chosen. At this stage the position of the station point should be checked with the cone of vision and adjusted if necessary.

The next step in the preparation of the 'special' plan is to locate the plan of the centre line of vision at right angles to the picture plane at a convenient distance from the ground plane (end elevation). By projecting across from the prepared elevation the 'special' plan can be drawn. Any dimensions (width) not obtained by projection can be obtained by measurement from the plan used to obtain the prepared elevation. All that remains is to locate the plan position of the station point by projection from the elevation. The construction is then ready for the preparation of a three-point perspective drawing of the object. (The plan position of the station point should be checked at this stage with the cone of vision and any necessary adjustments made before proceeding.)

The method for setting up a three-point perspective based on a two-point construction is as follows:

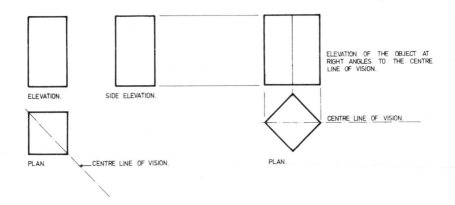

ELEVATION. SIDE ELEVATION.

ELEVATION OF THE OBJECT AT RIGHT ANGLES TO THE CENTRE LINE OF VISION.

CENTRE LINE OF VISION.

PLAN. CENTRE LINE OF VISION.

PLAN.

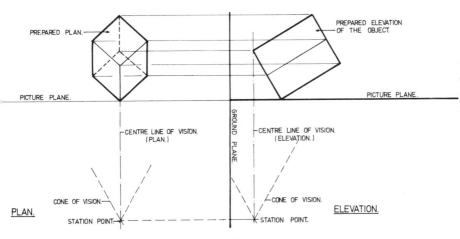

PREPARED PLAN.

PREPARED ELEVATION OF THE OBJECT.

PICTURE PLANE.

PICTURE PLANE.

CENTRE LINE OF VISION. (PLAN.)

GROUND PLANE

CENTRE LINE OF VISION. (ELEVATION.)

CONE OF VISION

CONE OF VISION.

PLAN.

STATION POINT.

STATION POINT.

ELEVATION.

64 Three-point perspective based on a two-point construction: obtaining the 'special' plan from the prepared elevation.

Step 1. Once the 'special' plan and the elevation have been prepared and set out as shown in Fig. 64 it is necessary to locate the vanishing points, including V.P.4 which in reality is not a vanishing point but the height above (or below) the horizon line at which V.P.1 and V.P.2 will be located.

V.P.1 and V.P.2 are located in the usual way by sight lines from the station point parallel to the sides of the object in the plan. V.P.3 and V.P.4 are located on the end elevation of the picture plane by drawing sight lines from the station point parallel to the sides of the elevation of the object (see Fig. 65).

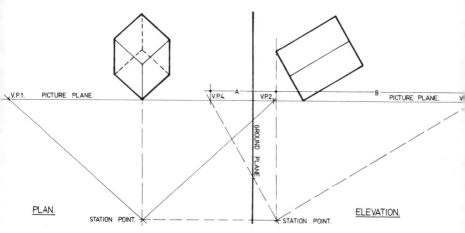

Step 2. The horizon line for the perspective drawing is located at a
convenient distance down on a continuation of the centre line of
vision in the plan. The ground line is located below the horizon
line at the distance shown in the elevation and is extended across
to meet the extension of the ground plane in the elevation. At
the intersection of the ground line and the ground plane a line
is drawn at 45° to both (see Fig. 66) so that the direction of lines
can be changed through 90° as described in Fig. 61.

Step 3. From the elevation it can be seen that V.P.4 is a distance
A below the point where the centre line of vision meets the end
elevation of the picture plane (horizon line), which means that
V.P.1 and V.P.2 will be located at height A below the horizon line.
To locate V.P.1 and V.P.2 a line is drawn at height A below the
horizon line in the perspective view and V.P.1 and V.P.2 are locat-
ed on it by projecting their positions down from the plan view of
the picture plane.

Step 4. V.P.3 (known as the 'vertical vanishing point') is located on
the extension of the centre line of vision (in the plan) by measur-
ing up from the horizon line the distance B which was established
in the elevation: the distance from the intersection of the centre
line of vision and the end elevation of the picture plane to V.P.3.

Step 5. The view of the object is drawn in perspective by using
projections from both the plan and the elevation as previously
described. All the points of the object are found in exactly the
same way, so that it is necessary to describe the location of only

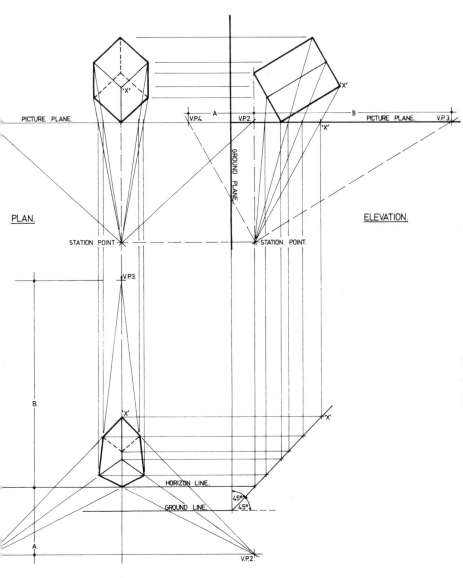

PICTURE PLANE. A V.P.4. V.P.2. B PICTURE PLANE. V.P.3.

GROUND PLANE.

PLAN.

ELEVATION.

STATION POINT. STATION POINT.

V.P.3.

B.

'X' 'X'

HORIZON LINE.

GROUND LINE. 45° 45°

A. V.P.2.

66 The construction of a three-point perspective
(based on a two-point construction) when the
object is inclined to the ground plane and viewed
from below.

one point here; the rest can be found by repeating the procedure
for each point.
Point *X* is located in both the plan and the elevation. From
point *X* in the elevation a visual ray is drawn back to the station
point. At the point where this visual ray meets the picture plane
a vertical line is drawn to meet the line drawn at $45°$ to the

81

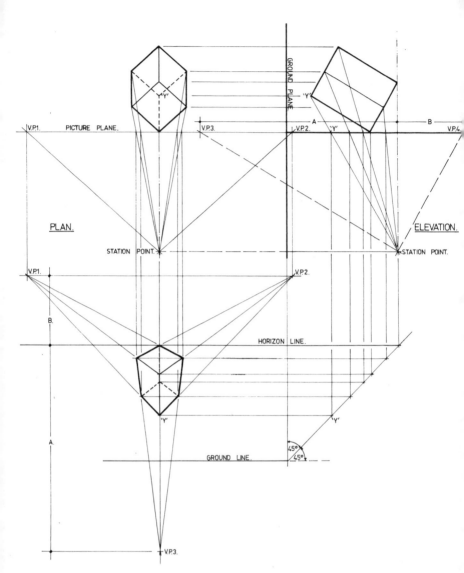

67 The construction of a three-point perspective
(based on two-point construction) when the object
is inclined to the ground plane and viewed from
above.

ground line. Here it changes direction through 90° and is pro-
jected across to meet a line drawn from the point on the picture
plane where a visual ray through the plan of point X meets it. In this
case point X in the plan falls on the centre line of vision and will be
located in the perspective view at the intersection of the visual ray
through point X in the elevation projected down and across and the
extension of the centre line of vision from the plan. The remaining

points of the object are found in the perspective view in exactly the same way. When all the points have been found all that remains is to join them up, using V. P. 1, V. P. 2 and V. P. 3 to produce the drawing of the object in three-point perspective.

When the object is inclined to the ground plane so that the spectator sees the top of the object instead of the bottom of it, the method is exactly the same as that described for the example shown in Figs. 64-66. In Fig. 67 the vertical vanishing point (V.P.3) is located *below* the horizon line and V.P.4 or the level of V.P.1 and V.P.2 is located *above* the horizon line – which is opposite to their positions when the object is inclined to the ground plane so that the bottom of it is visible to the spectator.

It can be seen from the examples of objects inclined to the ground plane, whether based on one-point or two-point constructions, that the principles are simply an extension of those discussed under the heading of 'inclined lines and planes in perspective' and, provided the main principles of perspective are thoroughly understood, three-point perspective is far less complicated than it may look at first.

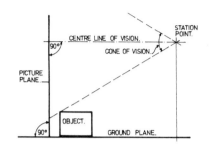

68 Station point too high: object becomes invisible.

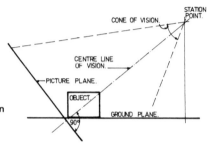

69 Centre line of vision and picture plane tilted: bird's-eye or aerial view.

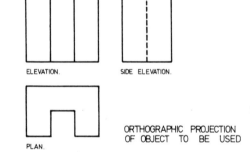

ELEVATION.

SIDE ELEVATION.

PLAN.

ORTHOGRAPHIC PROJECTION OF OBJECT TO BE USED

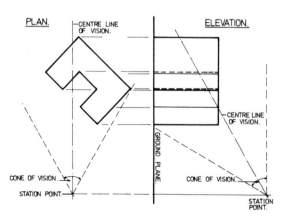

70 Setting up the plan and elevation for an aerial perspective: step 1.

4 Perspectives with an inclined picture plane

For the best view of an object the eye should be focused on or near the centre of it. Similarly, when producing a perspective drawing of an object the best results are generally obtained when the centre line of vision passes through or near the centre of the object to be drawn. The picture plane is always at right angles to the centre line of vision, so when the station point is in a horizontal plane through the object a vertical picture plane is used, i.e. one at $90°$ to the ground plane. The higher or lower the station point is located in relation to the object, the more necessary it becomes to use an inclined picture plane in order to achieve the best results.

Fig. 68 shows an object in relation to a high station point and it can be seen that these conditions make it impossible to produce a satisfactory perspective drawing using a normal, that is to say vertical, picture plane. (The object falls outside the cone of vision, which means that the drawing of the object will be distorted if attempted under these conditions.)

Fig. 69 also shows the same object and the same station point, with the centre line of vision depressed until it passes through the object and is thus no longer parallel to the ground plane. Because the picture plane is always at right angles to the centre line of vision it too will now be inclined to the ground plane. If the picture plane is inclined to the ground plane it will be seen that the conditions are similar to those shown in Fig. 59, where the object itself was inclined to the ground plane. Because of this the construction will also be similar: both require a third vanishing point ('vertical vanishing point'). However, this construction has one advantage over the other three-point constructions in that it does not require a 'special' plan but can be carried out using a normal plan. This is why this method is specially favoured for aerial, bird's-eye or worm's-eye perspectives.

To draw an aerial or bird's-eye view of the object shown in orthographic projection in Fig. 70 it is necessary first to locate the station point in the plan and the elevation. When this is done the method of setting up an aerial view of the object, i.e. a perspective drawing of the object using an inclined picture plane, is as follows:

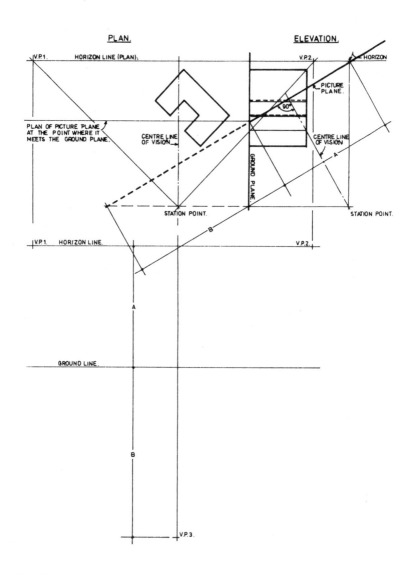

71 Setting up the plan and elevation for an aerial
perspective: steps 2-5.

Step 1. The selection of the station point is a matter of choice with-
in the limits of the cone of vision. When it is chosen, the plan is
rotated so that the centre line of vision is vertical, as shown in Fig.
70. A prepared elevation is necessary, and is obtained by drawing
at some convenient distance from the centre line of vision a
ground plane (elevation) parallel to the centre line of vision. The

elevation of the object can then be prepared in the normal way (by projection and measurement) and a suitable height above the ground selected for the station point. The centre line of vision is drawn in the elevation at the required angle to the object and the ground plane, remembering that usually the best results are achieved when the centre line of vision passes through the object to be drawn. The station point should be checked in both the plan and the elevation with the cone of vision and any necessary adjustments made.

Step 2. As previously explained, the location of the picture plane is a matter of choice and it is drawn on the elevation in the chosen position *at right angles to the centre line of vision.* (Fig. 71 shows the preparations necessary for an aerial perspective.)

Step 3. Because the picture plane is inclined to the ground plane it is necessary to locate the plan positions of the horizon line and the ground line (the plan of the picture plane where it meets the ground plane). As previously explained, the horizon line is always located on the picture plane at the point where a sight line parallel to the ground plane meets it. A sight line is drawn parallel to the ground plane in the elevation, and from the point where it intersects the inclined picture plane a horizontal line is drawn representing the horizon line on the plan view of the picture plane. From the point of intersection of the inclined picture plane and the ground plane in the elevation a horizontal line is drawn representing the intersection of these two planes in the plan view, i.e. the ground line.

Step 4. The location of the vanishing points for the lines parallel to the ground plane will be located in the horizon line and are located in the normal way except that because the picture plane is inclined the horizon line is visible in the plan, which means that the sight lines parallel to the sides of the plan of the object are drawn to the horizon line instead of the picture plane (plan) as in previous examples. V.P.1 and V.P.2 are located in this way and are the vanishing points for the horizontal lines of the object.

The vertical vanishing point (V.P.3) which will be the vanishing point for the vertical lines of the object is located on an extension of the elevation of the inclined picture plane by drawing a sight line parallel to the vertical lines of the object. In this example,

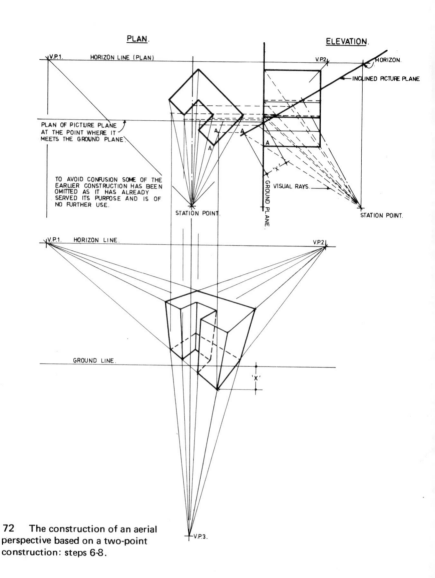

PLAN.

ELEVATION.

V.P.1. HORIZON LINE (PLAN)

V.P.2 HORIZON.

INCLINED PICTURE PLANE

PLAN OF PICTURE PLANE
AT THE POINT WHERE IT
MEETS THE GROUND PLANE

TO AVOID CONFUSION SOME OF THE
EARLIER CONSTRUCTION HAS BEEN
OMITTED AS IT HAS ALREADY
SERVED ITS PURPOSE AND IS OF
NO FURTHER USE.

GROUND PLANE.

VISUAL RAYS

STATION POINT.

STATION POINT.

V.P.1. HORIZON LINE.

V.P.2.

GROUND LINE.

'X'

V.P.3.

72 The construction of an aerial
perspective based on a two-point
construction: steps 6-8.

because the spectator is above the object, V.P.3 will be located at
a distance A below the ground plane in the elevation. The station
point is at a distance B above the ground plane. Using these two
measurements it is possible to locate the horizon line, the ground
plane and the vanishing points for the perspective drawing.

Step 5. From the plan view of the centre line of vision a vertical line
is drawn as a continuation of the centre line of vision, as shown in

Fig. 71. At a convenient distance down this line a horizontal line is drawn representing the horizon line in the perspective view. The positions of V.P.1 and V.P.2 are located on this horizon line by projecting down vertically from their positions in the plan view. At a distance *B* below the horizon line another horizontal line is drawn to represent the ground line in the perspective view. At a distance *A* below the ground line V.P.3 is located on the extension of the centre line of vision.

The construction is now completed and all that remains is for the perspective drawing of the object to be done.

Step 6. From the station point in the elevation visual rays are drawn through the points of the object to meet the picture plane (Fig. 72). The points where these visual rays meet the picture plane are transferred by measurement to the perspective view. (Point *A* on the object is followed through the construction to help the student understand the procedure.)

Step 7. From the station point in the plan visual rays are drawn through the points of the object. To locate the points where these visual rays meet the picture plane it is necessary to project lines across from the positions where the elevations of visual rays intersect the elevation of the picture plane. Where these lines projected across from the elevation meet the appropriate visual rays in the plan are the positions where the visual rays in the plan meet the picture plane. From these points where the visual rays in the plan meet the picture plane, projections are made down to the perspective view, and from these the points of the object can be located in the perspective view. (The heights above or below the ground line are located by measurement – see step 6.)

Step 8. By using V.P.1, V.P.2 and V.P.3 the points of the object are joined up to produce the drawing of the object in perspective using an inclined picture plane.

Fig. 73 shows the construction used for a worm's-eye view (seen from below). The method used for this example is identical to that used in the preceding one (Figs. 70–72). Because the station point is located at a lower level than it was in the previous construction the spectator will be looking up instead of down, so the vertical vanishing point will be located above the ground plane instead of below it. The method of construction is the same, and if Fig. 73 is

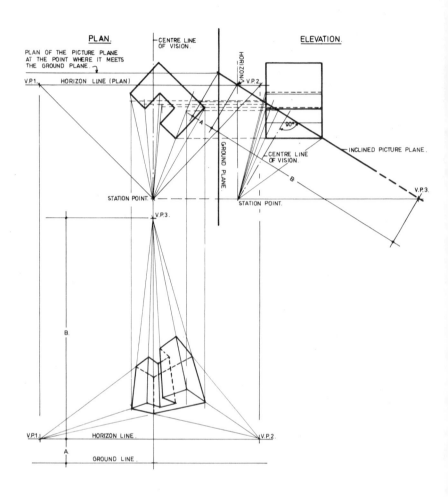

PLAN.

PLAN OF THE PICTURE PLANE
AT THE POINT WHERE IT MEETS
THE GROUND PLANE.

V.P.1. HORIZON LINE (PLAN)

CENTRE LINE
OF VISION.

ELEVATION.

HORIZON V.P.2.

INCLINED PICTURE PLANE.

CENTRE LINE
OF VISION.

V.P.3.

STATION POINT. STATION POINT.

V.P.3.

B.

V.P.1. HORIZON LINE. V.P.2.

A. GROUND LINE.

73 The construction of a worm's-eye view
based on a two-point perspective construction.

compared with Fig. 72, the method for drawing a worm's-eye view
will be easily understood.

Points located on the inclined picture plane in the elevation are
located in the perspective view by measurement. These measurements
are made along the picture plane, starting from the ground plane (in
the elevation). The ground line is the base line in perspective construc-
tions, and all measurements are made from it.

Fig. 74 shows the method used for drawing an aerial view of an
object based on a one-point construction. Again the method is

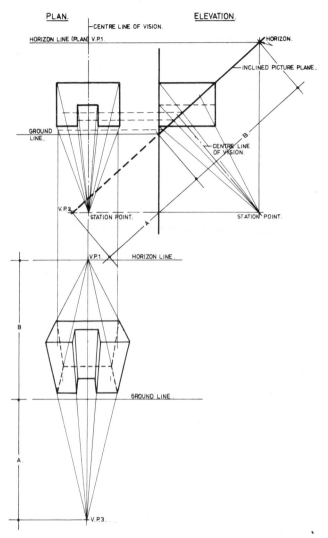

74 The construction of an aerial perspective based on a one-point construction.

similar to the one used for an aerial view based on a two-point construction, the only difference being in the placing of the object: in one-point perspective the object is located so that its sides are parallel either to the picture plane or to the centre line of vision, whereas in two-point perspective the object is located with its sides at an angle to the picture and the centre line of vision. The steps are carried out in the same order as for the two-point construction described in Figs. 70-72. (Note that the vertical vanishing point continues to be identified as V.P.3, to avoid any confusion.)

91

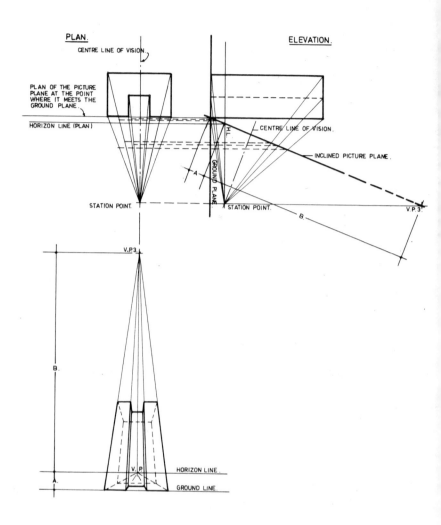

75 The construction of a view from a low station point (worm's-eye view) based on a one-point perspective construction.

Fig. 75 shows the method used for the construction of a worm's-eye view of an object based on a one-point construction. For this example the object shown in orthographic projection in Fig. 70 has been increased to twice the height to show to better effect the results obtained with a worm's-eye view. Again the method is similar to the previous examples of perspectives with inclined picture planes, and this can be verified by comparison of Fig. 75 with Figs. 72-74.

Conclusion

There are many problems with which the student will, no doubt, come into contact which are not answered directly in this book, but if the basic principles are understood many answers to specific questions can be found by applying these principles. There is no substitute for a sound basic knowledge of the principles of perspective, and even though there are a number of very useful short cuts these are of limited use unless they are combined with this knowledge.

Finally, it should be remembered that a perspective drawing is a technical drawing. Like any other technical drawing, if it is not accurate it is of little use to anyone. This is too often forgotten by the very people whose designs rely on the perspective drawing to convey their intentions to a client or the public.

Index

Page numbers in italics refer to illustrations.

accuracy, 29, 41, 63, 65, 69
aerial perspective, *see* bird's-eye
 view
'atmospheric effect', 9

bird's-eye view, 30-1, *82, 84,*
 85-9
 based on one-point, 90-1, *91*

centre line of vision, *16*, 16,
 18, 25, 36, 42, 43, 48
cone of vision, 16-19. *17, 18,* 37,
 43, 73
 in interior perspective, 50
convergence, *6*, 7, *8*, 10, 25

detail, effect of perspective on,
 9, 10
diminution, 7, 10
distortion, 15, 19, 24, 85
door, locating position of, 50-1
drawing, sequence of steps in,
 39, 45

elevation, 13, 14, 36, 41
eye level, 15; *see also* horizon
 line
eye position, 11, *11*; *see also*
 station point

'first-angle' projection, 14
foreshortening, 7, *8*, 10

ground line, 31-3, *32, 33*
 location of, 32, 38, 44, 48,
 74

height line, 27-9, 33, *33*, 39, 41
 location of, *28*, 37, 57, 66
 in one-point perspective, 42,
 44-55
horizon line, *29,* 29-31, *32, 33*
 location of, 30, 38, 44, 48,
 74, 80

interior perspective, 42
 one-point, 50-2, *51*
 locating a point in, 52-6

line, location of a single, 56-9
lines, inclined, 59-69

'one-look' principle, 11
one-point perspective, *34*, 35, 41-8
 setting up, 43-4, 46-7
 combined with two-point, 48,
 49
orthographic projection, *12*, 13,
 14, 36, *62, 64,* 72

perspective, special effects of,
 6, 7-10
picture plane, 19-25, *20, 21, 22,*
 23
 location of, 23, 24, 37, 43,
 47, 47-8

inclination of, 19
inclined, 85-92
plan, 13, 36
point, location of a, 52-6, *57*
projection, orthographic, *12,*
 13, *14*, 36, *62, 64,* 72
 'first-angle', 14
 'third-angle', 14

section, 13, *14*, 14-15, 36
shade and shadow, 7, *9,* 10
station point, 14-15, *16, 17,* 18
 selection of, *15*, 15, 24, *24,*
 36, 42, 43
 location of, 43, 73
 high, *84*, 85

texture and pattern, effect of
 perspective on, 10, *10*
'third-angle' projection, 14
three-point perspective, 35, *70,*
 71*ff.*
 'special' plan for, *72*
 based on one-point, 73-8

based on two-point, 78-83
tone and colour, effect of
 perspective on, 9-10, *9*
two-point perspective, 35, 36-41
 setting up of, 36-8, *41*
 combined with one-point, 48,
 49

vanishing point, *25*, 25-7. 35.
 40-1, 42
 location of, *26*, 27, *27, 30, 31,*
 37, 43-4, 74, 79, *80*
 for inclined lines (two-point),
 59, 60, 61-6
 for inclined lines (one-point),
 66-9
 vertical, 71, 80, 83, 85, 87-8
vertical projection, 20, *22,* 39
visual rays, 20, 39, 40, 66, 75-6

window, locating position of
 51-2
worm's-eye view, 31, *81,* 90
 based on one-point, 91, *92*